SEATTLE
PROHIBITION

**BOOTLEGGERS, RUMRUNNERS &
GRAFT IN THE QUEEN CITY**

BRAD HOLDEN

FOREWORD BY PAUL DE BARROS

THE
History
PRESS

Published by The History Press
Charleston, SC
www.historypress.com

First published 2019

Manufactured in the United States

ISBN 9781467140201

Library of Congress Control Number: 2018966320

CONTENTS

FOREWORD

Americans have long acknowledged that the "great social experiment" of Prohibition was a spectacular failure, not only because it was so thoroughly ignored by most of the populace, but also because of its unintended consequences, among them, the boost it gave to organized crime. Though the public has been slower to discern the parallels between Prohibition and the "war on drugs," it is encouraging to see that the same breed of moralists who brought us the Volstead Act are now being pushed back, state by state, when it comes to marijuana. Once a bastion of bluenoses, Washington can now claim that it was one of the first states (along with Colorado) to legalize recreational marijuana, and, as Brad Holden's captivating new book points out, also led the way in the microbrew movement, thanks to the liberalization of its liquor laws. If it's true that a Puritan is someone who has the sneaking suspicion that someone, somewhere, is having a good time, then Washington and its citizens, though we don't much like to brag, can be modestly relieved if not openly proud that we have joined the party.

As a jazz historian, I have inevitably been drawn to study the underworld social milieu that supported jazz in its first half century. There is an obvious overlap between the research I did for *Jackson Street After Hours: The Roots of Jazz in Seattle* and the present work. But I was unprepared for the cinematic detail Brad Holden brings to this story. Everyone knows about Roy Olmstead, the crooked cop turned bootlegger who supposedly signaled his deliveries over the radio. And sensationalized newspaper stories about

federal agents swinging their way into 1920s speakeasies with axes are also familiar to local historians. But who knew about bootleg thief "Pirate Jack" Marquett, dubious federal enforcer William Whitney, moonshiner Frank Gatt, rumrunner Johnny Schnarr, Canadian detective Forbes Cruickshank, bootlegger "Legitimate Pete" Marinoff and double agent Al Hubbard? What a twisted, tawdry tale of crossings, double-crossings and double-double-crossings Holden reveals here, complete with midnight shoot-outs on the choppy seas between Canada and the San Juans and stakeouts along the shore! This is crazy, fun stuff.

On a more serious cultural note, this tale of how our forefathers and foremothers repressed the popular (and apparently irrepressible) impulse to drink—often, it must be said, with the best of intentions, as women sought to protect themselves from drunken husbands—is also a timely reminder that the same pious zealots who outlawed drinking were also—sometimes wittingly, sometimes not—waging a war against Seattle music. For it was not only alcohol that was driven underground in Seattle by Prohibition, but dancing, too, and the joyous, sensual celebration of song, a tradition that extended well beyond 1920s mayor Bertha Landes's war on dance halls into the recent past, with the odious (and eventually repealed) teen dance hall ordinance. But music, like the human spirit itself, has a way of enduring. Pass whatever laws you like, ecstasy will somehow find its way into basement caverns and secret hideaways, where you will find people drinking, singing, dancing and celebrating. In the last few decades, thankfully, such celebrations have come out of hiding, welcomed and honored as a crucial part of Seattle's cultural fabric. Brad Holden's fascinating tale recalls a time when they were still struggling underground.

—PAUL DE BARROS
December 18, 2018

ACKNOWLEDGEMENTS

This was an incredibly fun book to write, but it wouldn't be possible without the help of several people. Starting things off, a giant thanks to Kurt Stream (author of *Brewing in Seattle*) for planting the book-writing idea in my head during a conversation we had. Another big thanks to Arcadia Publishing acquisitions editor Laurie Krill, who has been an absolute godsend with patiently helping me navigate this whole process. Next, I would like to offer my deep and sincere gratitude to Jewelli Delay (great-granddaughter of Frank Gatt), who sat down with me and shared her family stories as well as all the photographs of the infamous moonshiner that are included in this book. Her book, *The Gentleman Bootlegger: The Story of Frank Gatt*, is highly recommended for anyone interested in this chapter of Seattle history. Likewise, my deep gratitude to Patricia Olmstead for the terrific phone conversations we shared about her father, Roy Olmstead, as well as Katie, his great-granddaughter, for all her assistance. Being able to talk to the descendants of these local historical figures was nothing short of amazing. During the research of this book, I also became involved in the exciting discovery of a famous speakeasy that was found during a recent building renovation in the International District of Seattle. The story of this speakeasy is covered in the book, but a big thanks to the building's owner, Tanya Woo, for allowing me such access. In the same light, I would like to offer my thanks to very knowledgeable Capt. Gene Davis, who runs the fantastically curated Seattle Coast Guard Museum, where I found an incredible array of photographs and resources pertaining to Pacific

Northwest rum-running. A big thanks also goes to Paul de Barros, who graciously penned the foreword to this book. Paul is a music columnist and local historian whose excellent book, *Jackson Street After Hours: The Roots of Jazz in Seattle*, is a must read. Lastly, none of this would be possible without the patience, encouragement and understanding of my wife and daughter. I love you both!

PROLOGUE

Seattle's contentious relationship with booze goes all the way back to when a small group of devout settlers first landed upon its shores in 1851. The acknowledged leader of this group, Arthur A. Denny, was described as a dour man whose ascetic religious beliefs gave him a lifelong disdain toward liquor. Denny was such a teetotaler, in fact, that he refused to stock any alcohol at his general store and would instead send customers out to buy their whiskey directly from visiting merchant ships rather than deal with the transaction himself.

Other pioneers soon started arriving at this new frontier town, including a man by the name of David Swinson "Doc" Maynard, who, to the chagrin of Denny and others, operated under a much different moral compass. Doc Maynard, as he was commonly known, believed that vice was essential to the economic development of any newly formed town and helped establish Seattle's first brothel, run by the infamous Mary Ann Conklin, who was known to most residents as Madame Damnable due to the nature of her business and the fact that she could curse in several different languages. Maynard also loved to drink, which certainly caused its share of town strife. One of his early business ventures was a seafood enterprise in which he attempted to fill hundreds of barrels with salt-cured salmon that he could then sell to visiting ships. Unfortunately, Maynard became so inebriated during the crucial salting stage of the operation that his ratios were way off, resulting in hundreds of barrels of rotting fish that stunk up the entire area and provoked the ire of everyone within a ten-mile radius.

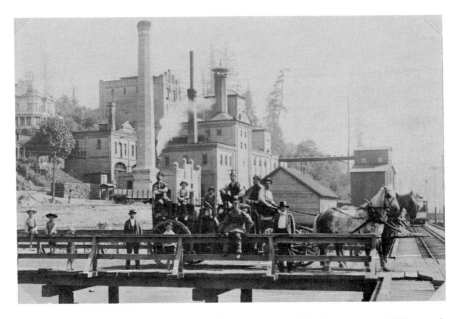

Bayview Brewery, 1898. The name derived from its view of Elliot Bay. *Courtesy of Museum of History and Industry (MOHAI).*

Despite Maynard's drunken antics, the new logging town became a wildly popular destination and its first brewery opened in 1854, just three years after the arrival of the Denny Party. At the same time, local political forces were at work trying to bring things in a much different direction. In 1855, the Washington Territorial legislature placed a referendum up for vote which would have outlawed the sale and manufacture of alcohol. It was the area's first attempt at prohibition. The measure was defeated but was certainly a political omen of things to come.

As Seattle grew, so did its love of vice, which many attributed to Maynard's licentious influence. By the 1880s, the city hosted several saloons, gambling parlors and brothels. In 1888, Lou Graham set up her infamous bordello on the corner of Third and Washington, and it instantly became one of the top gathering places for many of Seattle's business and political elite. It was remarked that more city business was conducted at Graham's parlor than at city hall. Graham's influence was so powerful, in fact, that when the Great Seattle Fire of 1889 wiped out most of the city's buildings, her brothel was the first to be rebuilt. In 1896, gold was discovered up in Alaska and Seattle became the official port city for this popular new destination. Thousands of new people flooded into the city, either on their way to the Alaskan goldfields

or hoping to cash in on all the money pouring into the local economy. This influx of people and money meshed with Seattle's already well-established foundation of sin and, before long, saloons, gambling parlors and brothels dotted the entire city.

Not everyone was enamored with all this illicit activity, however. The Reverend Mark Matthews, who would eventually establish the powerful Seattle Presbyterian Church, began standing on downtown street corners, preaching about the evils of booze and the hellish dangers of the saloon. The Anti-Saloon League started mobilizing its local army of ardent prohibitionists and the Woman's Christian Temperance Union would soon utilize a new law allowing women the right to vote as a powerful weapon in its crusade against the evils of alcohol.

This incongruous relationship with vice continued into the early 1900s as Seattle became divided between "Open Town" and "Closed Town" factions. Open Town advocates wanted all vice confined to a specific section of town, while Closed Town proponents were adamant that no such activity should be permitted at all. In 1915, Washington voters decided to make the entire state a closed town when State Initiative 3 made the manufacture and sale of alcohol illegal. Four years later, the Eighteenth Amendment was passed, making alcohol illegal nationwide. Unfortunately, this new law did very little to help broker peace between the two sides. It only ignited a new war that would last nearly twenty years and be spectacularly played out across Seattle's streets, waterways and even its town hall. Good men would be sent to jail, bad men would be given badges and people everywhere would feel its effect. This new era would become known as Prohibition, and this is its local story.

THE SALOON YEARS

*We learned our social and political fundamentals bellied up to the bar.
I cannot recall that we ever got drunk, but upon occasion we were moderately
stimulated and inspired to create and announce improvements in government,
or denounce social inequities.*
—Seattle newspaper reporter Jim Marshall,
recalling local saloon culture during the 1880s

That Prohibition was an indictment against alcohol is, in many ways, a popular misconception. More specifically, it was a legal retaliation against the places where alcohol was served. Saloons, as they were known, had grown to become the social bogeymen of their time and would eventually be the driving force for America going dry under the Eighteenth Amendment. The starting point for all this goes back to the years immediately following the Civil War when a huge wave of German immigrants began settling here in America. These German newcomers brought with them their love of beer and soon began establishing traditional breweries that bore the Germanic surnames of their respective founders: Anheuser, Pabst, Schlitz.... Attempting to re-create the crisp lagers from their homeland, most of these breweries combined native brewing techniques with local ingredients to create a distinctly American beer that quickly became a hit with the working class. In Seattle, Andrew Hemrich established his own brewing empire, eventually founding the Seattle Brewing & Malting Company that would go on to produce the city's most iconic beer, Rainier.

In an attempt to increase sales, many of these big breweries began setting up drinking establishments where the public could gather and enjoy their product, similar to the beer halls and brewpubs of their homeland. These German beer parlors colloquially became known as saloons, as that was already a popular term in use to describe a drinking establishment. To help entice new customers, free food was typically offered, such as cold cuts, pretzels and smoked fish. This certainly helped boost their popularity amongst the working class. By the late 1800s, beer saloons had become increasingly popular in urban areas throughout Washington State. They offered a place where men could gather to eat, drink and discuss daily affairs. Voting and banking services were commonly offered, providing a place where customers could cash their paychecks or cast votes in local elections. Overall, they were fairly honorable and respectable places where drunken behavior was relatively uncommon in favor of civil discourse and the slow imbibing of lager. These saloons provided a meeting place where one could find fellowship and good conversation, and where beer was more of a social lubricant than an intoxicant. A Seattle newspaper article at the time described the saloon as "a place where all men were equal and every man was a king."

The majority of Washington State saloons at this time were located almost exclusively in urban areas such as Seattle, Olympia, Tacoma and Spokane. There were a few reasons for this. For one, saloons were typically owned and controlled by nearby breweries, as it ensured a location where only their beer would be sold. This type of arrangement, similar to the "two-tiered" systems found in Great Britain, helped breweries control the local market, which, in turn, allowed them to control the price of their beer. Thus, the more saloons that a brewery owned, the more of its beer that could be sold. From a logistical standpoint, though, breweries were quite limited in how far they could transport their product. Beer was not being pasteurized at this time, meaning it had a short shelf life and needed to be consumed quickly. Breweries also relied on horse-drawn beer wagons to deliver their product, limiting their delivery range to nearby streets and roadways. This kept saloons geographically anchored to their respective breweries and, as a result, they were seldom found outside of large metropolitan areas.

By the time Washington attained statehood in 1889, the nature and scope of saloons were beginning to change. The advent of transcontinental railroads allowed various items to be transported farther than ever before, and the Anheuser Brewery, in St. Louis, had recently patented the refrigerated boxcar, allowing perishable items to be transported across the entire country

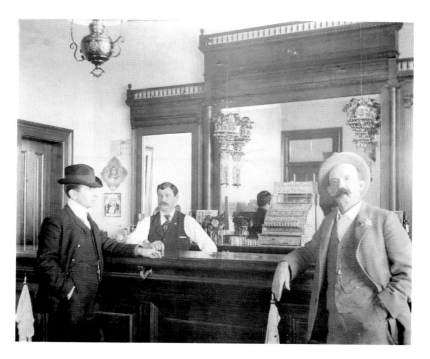

Seattle saloon, circa 1890s. *Author's collection.*

with relative ease. Breweries were also beginning to pasteurize their beer, allowing for a much longer shelf life. Adding to all this, crown bottle caps, which allowed beer to be sealed in individual bottles, were introduced in 1892. All these innovations now meant that large quantities of beer could be safely delivered to areas outside of a brewery's immediate vicinity. In Washington State, companies such as the Great Northern Railway and Northern Pacific were in fierce competition with one another and, within a relatively short period of time, newly built railroad lines that crisscrossed the state opened up easy and affordable commerce between urban and rural locations. This included the transfer of beer and alcohol. Brewers certainly took notice of this and began setting up saloons along railroad routes in order to increase their market share. In the span of just one year—between 1889 and 1890—Washington State beer sales increased by 33 percent, a direct result of these new railway routes.

As a result of all this, saloons began proliferating across the rural landscape at a dramatic rate. Unlike their urban counterparts, however, these smaller towns lacked the social infrastructure and evolved cultural nuances to properly handle such drinking establishments. Whereas the urban brewpub

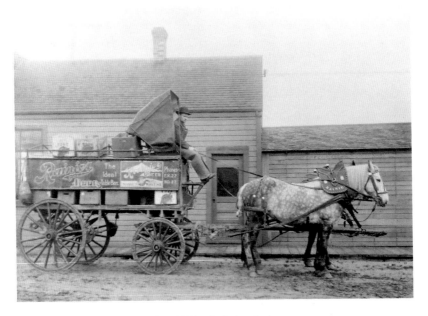

Rainier Beer delivery wagon, late 1890s. *Author's collection.*

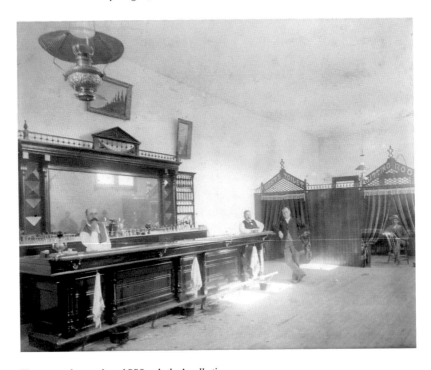

Tacoma saloon, circa 1890s. *Author's collection.*

served as a civil gathering spot for enlightened conversation, rural saloons almost immediately established themselves as rowdy destinations where intoxication, violence and disorderly conduct disrupted the tranquility of small-town living. They were places where men went to drink and brawl and, amongst these bucolic communities, the whole thing felt like an immoral invasion. Stories emerged of families thrown into poverty and neglect due to the men spending all their time and money at the saloon. Rates of domestic violence and alcohol-related arrests spiked up, as did the rates of divorce. This followed national trends associated with the proliferation of saloons and the unintended social problems that accompanied them.

While saloons spiraled out of control throughout rural Washington, the once gentle nature of Seattle's beer joints also began to transform. Major events, like the Yukon Gold Rush of 1896, had attracted thousands of people to the city, and local vice syndicates were happy to help satisfy their needs. No longer just controlled by local breweries, a new generation of saloonkeepers and parlor house owners emerged who were eager to cash in on all the gold rush money ("mining the miners," as the catchphrase became known). Before long, saloons, cigar stores, gambling parlors, dance halls and brothels popped up all across the city, most of them located south of Yesler Way in an area that became known as the Tenderloin District. A large population of "seamstresses" suddenly began advertising their services in the Tenderloin and, while nobody ever witnessed any actual sewing, the boardinghouses where they lived sported telltale red lights.

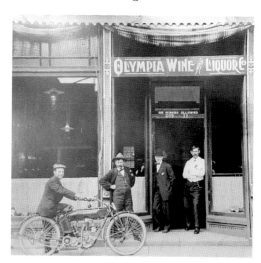

Olympia Wine & Liquor Co. in Olympia, Washington, circa 1910s. *Author's collection.*

This neighborhood, which had already earned a notorious reputation well before the gold rush days, was now becoming even more dissolute. At any given time, the streets would be crowded with men looking for a good time. Lou Graham and other parlor house owners would parade their girls up and down the streets on ornately decorated carriages. Barkers would stand outside the doors of saloons and loudly try to entice new customers into their establishments amid the excited clatter of nearby gambling halls, billiard parlors and the all too frequent street fight. Adding to the adventurous excitement, there was also the constant threat of being shanghaied, in which men were drugged and rendered unconscious (usually in the setting of a saloon), and would then have their signatures forged on papers that committed them to compulsory service aboard a ship. The next morning, the man would wake up from his stupor and find himself as an enslaved crewman aboard some unknown ship bound for a foreign port. During the gold rush days, shanghaied sailors would usually find themselves on ships headed for Alaska. It was so prevalent, in fact, that the *Seattle Star* warned its readers that shanghaiing was being practiced in the vice district to "an alarming extent." The Tenderloin ran twenty-four hours a day, though nights were particularly rowdy. One newspaper account at the time summarized the scene as "sin, vice and crime sneak forth like human wolves only after the sun goes down."

From this, a new type of institution evolved in which all forms of vice blended together and became available at one convenient location. Boxhouses, as they became known, were saloons which also offered gambling, narcotics and prostitution. Typically, a stage was set up in which female dancers (in an early version of burlesque) would dance and perform in a suggestive manner for the entertainment of those inside. If the male patrons liked what they saw, there were private cubicles, or "boxes," along the walls in which certain other transactions could be negotiated. Many of these rooms contained a single couch or small bed which, according to local religious leaders at the time, permitted "immorality in its most depraved form." One popular boxhouse, located on an Elliot Bay pier, was known for having trapdoors hidden in the floor. If a customer became too drunk or belligerent the saloonkeeper would simply pull a lever, sending the person plunging into the cold Puget Sound waters below.

The so-called king of these boxhouses was a man by the name of John Considine. Considine himself was a teetotaler but operated his saloons with a tenacious business sense, controlling much of the city's gambling, drinking and prostitution revenue. He used the People's Theatre, one of the

city's largest boxhouses, as his headquarters. So strong was his grip on the local underworld that he famously chased notorious gunslinger Wyatt Earp out of town. Like many others before him, Earp had attempted to cash in on all the Alaskan Gold Rush money flowing into the city by setting up the Union Club—a saloon and gambling parlor—in the heart of Seattle's vice district. Considine took notice of this new competition and personally advised Earp to leave. The famous gunslinger not only disregarded this advice but used his celebrity status to establish the Union Club as one of the city's most popular saloons. Fed up, Considine made use of his local political connections, and on March 23, 1900, criminal charges were filed against Earp and his business partners. The club's furnishings were confiscated and burned and Earp was essentially chased out of town. Despite his battles with the famous gunslinger, Considine formed symbiotic partnerships with other saloon owners. This included the notorious William Belond, who operated the popular saloon Billy's Mug at First and Washington. Billy the Mug, as he was commonly known, had a reputation for being one of the toughest saloon owners in Seattle and was well known for grabbing rowdy customers by the scruff of the neck and forcibly throwing them through the front door and out onto the street. His saloon certainly reflected his own roughhouse character as he frequently hosted cockfights and pit bull fights with his bar packed full of loud and drunk customers shouting out their bets. Billy's boasted a fifty-foot-long bar where skilled barkeeps such as Herman Butzke, the famous singing bartender, would expertly slide mugs of beer down the narrow bar and precisely land them in front of customers. For a mere nickel, Billy's Mug offered a "quart and a gill" (essentially two and a half pints of beer), with a free schooner given to whoever could down it in one breath. Considine negotiated a deal with Billy in which he operated the rooms above the saloon to serve as a gambling joint known as the Owl Club. Considine's vice empire was growing by the month, and his boxhouses were known for having the most beautiful and entertaining stage performers, including the then-famous belly dancer, Little Egypt.

In 1901, Considine had a falling-out with Seattle police chief William Meredith. The feud between the two men escalated, resulting in a very public war of words and, eventually, a shoot-out at a downtown drugstore. In the violent melee that followed, Meredith was fatally gunned down and Considine arrested. Later acquitted of the subsequent murder charges on grounds of self-defense, Considine would decide to go "legit," using his boxhouse experience to help cofound a new, successful form of entertainment that would eventually become known as vaudeville.

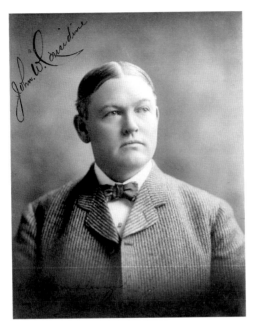

Left: Seattle boxhouse lord and vaudeville impresario John Considine, 1908. *Courtesy of Museum of History and Industry (MOHAI)*.

Below: William Belond, otherwise known as rowdy saloon owner Billy the Mug, 1897. *Courtesy of Museum of History and Industry (MOHAI)*.

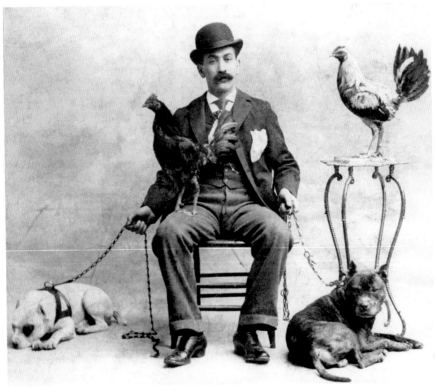

It didn't take long for a moral backlash to begin forming against all this. For many local religious groups, the levels of vice in Seattle and the proliferation of saloons throughout the state had become too much and immediate action needed to be taken. In the Midwest, groups such as the Woman's Christian Temperance Union (WCTU) and the Prohibition Party had become powerful social and political forces intent on shutting down these troublesome establishments and bringing temperance to the masses. This anti-saloon sentiment soon spread throughout Washington, representing a larger and broader attitude that would soon engulf both local and national elections.

CHAPTER TWO

THE PREACHER
AND THE MAYOR

The saloon is the most fiendish, corrupt, hell-soaked institution that ever crawled
out of the slime of the eternal pit....It takes your sweet innocent daughter,
robs her of her virtue, and transforms her into a brazen, wanton harlot....
It is the open sore of the land!
—*Reverend Mark A. Matthews of the Seattle Presbyterian Church*

Of all of Seattle's mayors, none have had a more controversial tenure than
that of Hiram Gill. Arriving in Seattle as a brash, young attorney in
1892, Gill was able to recognize an unfilled niche amongst the vice-filled
city and soon established a thriving legal practice defending saloonkeepers
and brothel owners. His business proved to be a success, but Gill had loftier
ambitions than keeping saloon owners out of jail. In 1898, he was elected
to the Seattle City Council, serving on and off as a Republican candidate
until 1910. His peculiar looks and controversial past made him a favorite
target with the local media, with one reporter describing him as having "a
pinched triangular face, a nervous, twitching mouth and keen but shifty blue
eyes." During this time, as vice spread across the city, Seattle politics became
divided between "Open Town" and "Closed Town" factions. Open Town
proponents believed that alcohol, prostitution and gambling were normal
human activities and should be permitted as long as they were regulated and
restricted to a certain part of the town. Closed Town advocates, including
local clergy and temperance leaders, lobbied that no such conduct should be
permitted at all and should be aggressively enforced.

One of the most prominent figures on the Closed Town side was local Presbyterian minister Mark A. Matthews. Known as the "black-maned lion" due to his long, thick head of hair, the tall and lanky Matthews had firmly established that he was on a mission to rid Seattle of sin and corruption and was known to give impassioned soapbox sermons near busy saloons. Gill, on the other hand, was a well-known Open Town advocate who was seen as a rising political star from his time on the city council. That there would be hostilities between the two men was inevitable. Matthews launched the first strike in 1905 when he publicly accused the city councilman of graft, adding that Gill condoned vice and had once left a city council meeting to bail a gambling hall owner out of jail. These accusations were never proven but, given Gill's background, were probably not without merit. Gill was incensed and wasted no time in firing back, telling local newspapers that Matthews had been run out of Tennessee for running a craps game and that he was currently "entangled with a disreputable woman of the underworld." For a married clergyman such as Matthews, these were brutal accusations indeed. The famous feud between the two men had officially begun and would be one that would have lasting consequences for the entire city.

While the Gill-Matthews fracas was gathering steam, saloons and boxhouses continued to proliferate throughout the city, as did the religious and political forces opposed to them. Washington State quickly developed a vigorous temperance movement, including the Prohibition Party, which established a branch here in 1869, soon followed by the Woman's Christian Temperance Union (WCTU). The WCTU had its start in Ohio in 1873 and, within a relatively short period of time, was operating on a national level. The stated purpose of the WCTU was to rid the world of the evils of alcohol through the purity of Christianity. Its primary target was the saloon, and a common tactic was to stand outside such establishments singing traditional church hymns and offering loud prayers for the men drinking inside.

In other parts of the country, more aggressive tactics were being used. Kansas WCTU activist Carrie Nation was quickly gaining notoriety for entering Midwestern saloons and destroying everything inside with a hatchet. This led to the hatchet becoming the unofficial symbol of the temperance movement. The WCTU saw itself as a protector of children and families and, within a few years, had galvanized to become one of the nation's most powerful social movements. In addition to protesting saloons with prayers and hymns, the WCTU was also very active in the suffrage movement, for members knew what profound changes could be accomplished if women were finally granted the right to vote. In 1883, the WCTU established itself

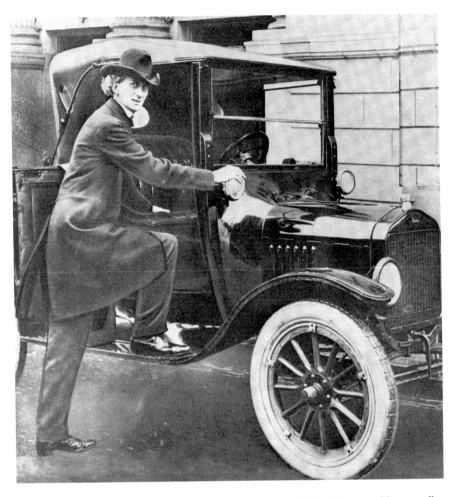

Influential minister the Reverend Mark Matthews in the 1910s. Matthews would eventually found the Seattle Presbyterian Church, regarded by many as the world's first megachurch. *Courtesy of University of Washington's Special Collections.*

here in Washington with chapters in both the eastern and western parts of the state. In 1884, the western chapter held its first meeting in Seattle, and it was, by all accounts, a boisterous and very well-attended gathering. By the early 1900s, the local WCTU was a thriving organization and the western chapter moved its headquarters to downtown Seattle in the Arcade Building.

At the same time, an even more powerful organization had formed with its intentions explicitly reflected in its name. The Anti-Saloon League established a local chapter here in 1893 and by the early 1900s had become the most powerful and militant of all the temperance groups. Its power

lay within the way it structured itself with a wide network of evangelical churches tied together under the direction of a centralized authority. Each church acted as a basic organizational unit that could spring to action when needed. The Seattle chapter of the league was run by Ernest Cherrington, a Midwestern writer, saloon fighter and editor. Cherrington started a local newsletter called *Citizen*, which helped to build up a strong following of local churches and provided editorial content that helped to politically sway local elections toward favoring dry candidates. He was a master at creating a strong anti-saloon sentiment and had soon built up a highly organized political movement dedicated to the prohibition of alcohol. Adding to the strength of the Seattle roster was local prohibitionist and rising political star, George Cotterill. In 1906, the Anti-Saloon League held a large convention in Seattle. The Reverend Mark Matthews and Cotterill both gave impassioned speeches at the convention, with crowd favorite Matthews riling the audience up with one of his fiery sermons.

The influence of the Washington State Anti-Saloon League was indisputable, and it soon claimed one of its first political victories with legislation known as "local option." Passed in 1909, local option allowed individual towns to hold special elections to decide whether or not saloons should be allowed within their jurisdiction. Washington temperance groups celebrated this as an opportunity to vote the state dry one municipality at a

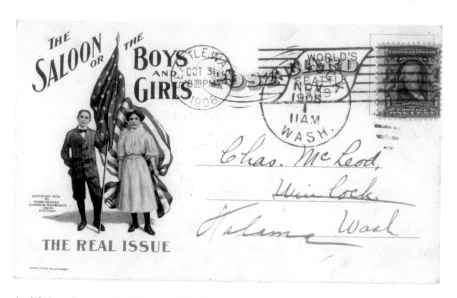

Anti-Saloon League Card from the Washington State chapter, 1908. *Author's collection.*

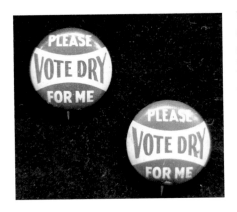

A pair of "Vote Dry" pinbacks from Washington State temperance groups during their "Local Option" efforts in 1909. *Author's collection.*

time. Once a town decided to hold a local option election, groups such as the WCTU and Anti-Saloon League would mobilize their efforts and hold rallies, parades and voter registration drives and engage in heavy campaigning. As a result, several local towns voted to become dry, including Edmonds, Everett and Bellingham. Six entire counties also went dry: Cowlitz, Garfield, Island, Klickitat, Mason and San Juan. The temperance movement claimed other political victories as well. The same year as local option legislation, Washington passed the "Sabbath Breaking Law," which prohibited most businesses in the state from operating on Sundays. Likewise, so-called blue laws were enacted which prohibited gambling or the sale of alcohol on Sundays. The proverbial noose was quickly tightening around the neck of the alcohol industry as saloon owners saw their business empires being whittled away by the persistence of this newly energized temperance movement.

This growing anti-saloon sentiment was also reflected in the Seattle political machine. On May 13, 1909, Mayor John F. Miller, a dry Republican, ordered his police force to begin cracking down in the Tenderloin and five illegal saloons were raided and shut down in a single day. Participating in these raids was a young, baby-faced patrolman with a mischievous twinkle in his eyes. The badge on his uniform identified him as Olmstead, but fellow officers on the force simply called him by his first name, Roy. Olmstead was well-regarded for his intelligence, ambitiousness and hard work ethic and was seen as a rising star within the department.

Immediately south of the city limits, the rowdy Georgetown neighborhood was resisting annexation while operating as a company town for the Seattle Brewing and Malting Company. With its proximity to hop-growing areas along the Duwamish River, the brewery was producing ample quantities of its popular Rainier brand of lager and grew to become the sixth-largest brewery in the world. With a growing temperance movement nipping at its heels, this thriving beer factory was intent on safeguarding its business interests, so it essentially set itself up as an insular company town. The

superintendent of the Seattle Brewing and Malting Company began serving as Georgetown's mayor, presiding over the majority of the workers living within the town's boundaries. With the brewery serving as the sociopolitical epicenter of this small town, the number of saloons and brothels proliferated, much to the ire of the nearby moral community. Other nearby attractions had also caught the attention of local temperance groups, including Luna Park, a popular West Seattle amusement park that boasted an assortment of rides, including a hand-carved carousel and the Great Figure Eight Roller Coaster. At night, however, the park's biggest attraction was its bar, which billed itself as the longest and best-stocked bar on Elliot Bay. This drew an assortment of unsavory characters, causing the *Seattle Post-Intelligencer* to send one of its reporters there on a Sunday night. In the shocking article that followed, the lurid scene at the Luna Park bar was described as "girls hardly 14 years old, mere children in appearance, mingled with older, more dissipated patrons and sat in the dark corners drinking beer, smoking cigarettes and singing." Local religious groups were aghast. It certainly didn't help that the amusement park's logo was a picture of a grinning devil with the slogan "Meet Me At Luna Park."

While all this was going on, Hiram Gill was actively campaigning on the Open Town platform in which he advocated that all vice should be confined to the Tenderloin district rather than be allowed to spread across the city, and Gill had emerged as a leading mayoral candidate. While out campaigning, he promised that "this district will be the most quiet place in Seattle...the redistricted district under me will be located in a place where men will have to go out of their way to find it." Gill also let it be known that he wasn't a big fan of the Sunday blue laws, remarking in one speech, "I want bands to play in Seattle. I want them to play on Sunday." Comments like this certainly didn't earn him the endorsement of Matthews, who used his pulpit to regularly attack Gill.

Despite rigid pushback from the city's reformers, Gill's open town politics won him wide support and, in one of the greatest voter turnouts in the city's history, he was elected Seattle mayor on March 8, 1910. In his victory speech, Gill remarked, "I don't pretend to be a very good man, but I know the law and will enforce it." Among those sending congratulations to Gill was John Considine, who even offered Gill the opportunity to give a political monologue on one of his local vaudeville stages. Opponents of Gill, however, called into question some of the spurious methods that were reportedly used by the Gill campaign, including that he imported unemployed men into the city, lodging them in vacant houses and

apartments in exchange for their illegal votes. Despite these charges, Gill was soon sworn into office and wasted no time courting controversy by appointing Charles Wappenstein as his chief of police. "Wappy," as he was commonly known, had gained notoriety after being dismissed years earlier while serving under former police chief John Meredith (who was later killed in the famous shoot-out with John Considine). Wappenstein had been found to be on the take with multiple gambling parlors and brothels, and so had been summarily expelled from the police force. Described as a "disreputable walrus," in part due to his large moustache, Wappy had previously been selected to be head of security for the Alaska Yukon Pacific Exposition (Seattle's first world's fair, held in 1909), though there was widespread concern at the time that he would figure out a way to steal from the event. Wappenstein proved to be a good match for the city's new mayor, and in no time at all, the new administration demonstrated itself to be far more "open" than anything Gill had advocated for.

Gambling, prostitution and saloons all flourished under Gill's mayoralty, but usually for a price. Gill and Wappenstein set up a system where they collected ten dollars a month in payoff money from each of Seattle's working prostitutes. Those who refused to pay were arrested. Gill also bought an interest in the Northern Club, which, at the time, was one of the

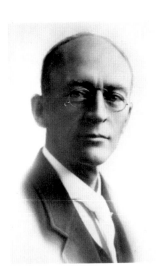

city's largest gambling halls, and he accepted kickbacks from local companies in exchange for city contracts. Worst of all, at least in the eyes of the city's reform movement, was that Gill had broken his promise to confine vice to the Tenderloin and had opened the entire city to gambling, drinking and prostitution. These new enterprises were reportedly running twenty-four hours a day, including Sundays, which some felt was Gill thumbing his nose at his evangelical critics. Things were off to a lucrative start for this new mayor, though not without drawing a lot of unwanted attention. A popular magazine at the time, *McClure's*, even featured an article describing the state of illicit affairs in Seattle, reporting that

Hiram Gill toward the beginning of his scandal-plagued political career. *Courtesy of Seattle Municipal Archives.*

the city seemed to have been transformed almost magically into one great gambling hell. All

kinds of games simultaneously started up, in full view of the public. Cigar stores and barbershops did a lively business in crap-shooting and race-track gambling, drawing into their patronage largely from school boys and department store girls. At one time it looked as if the whole of Seattle were going mad over faro, roulette, blackjack and numerous other forms of entertainment provided in the thirty or forty gambling places opened up under the administration of Hi Gill.

His old foe, the Reverend Matthews, certainly took notice of all this and hired the William Burns Detective Agency to quietly investigate these matters. What the detectives would eventually discover would shock the entire town.

The same year that Gill was elected as mayor saw women in Washington State win the right to vote. Or, more accurately, they regained the right to vote, as they had previously been granted the right to vote in 1883 but had these rights repealed in 1888. Nevertheless, this was celebrated as a huge victory and helped propel the local WCTU into action, immediately setting its sights on moral reform as well as bringing down the corrupt administration of the new mayor. And while the William Burns detectives started their investigation into Mayor Gill's activities, Matthews himself was busy setting up the Seattle Presbyterian Church. At a time when Seattle's level of vice was growing more widespread by the day, Matthews's anti-saloon sermons resonated with a large chunk of the city's more moral-minded population. His newly formed church quickly grew to over 10,000 members, making it one of the world's first megachurches. With such a large congregation, Matthews used his pulpit to become one of the city's leading reformers, which perfectly meshed with the stated goals of the newly enfranchised WCTU, as well as the Anti-Saloon League. Naming themselves "The Forces of Decency," these moral forces had united to become a political powerhouse that would soon be celebrating many important victories.

Over in the working-class neighborhood of Beacon Hill, local residents took notice of a large, new building that was suddenly being constructed. Two local vice lords had decided to try their hand at being land developers and, after buying Gill's approval for a fifteen-year lease, proceeded to build a five-hundred-room brothel, the largest such establishment in the world. One of its principal investors was W.W. Powers, manager of nearby Luna Park amusement park. This mammoth bordello opened in August 1910, unintentionally serving as an architectural symbol of the Gill administration. Naturally, it immediately caught the attention of Matthews's hired detectives,

A 1919 membership card from the Seattle Presbyterian Church, signed by the Reverend Mark Matthews. *Author's collection.*

who were easily able to follow the money trail back to Gill and Wappenstein, leading to a bruising political scandal. Amid the city's widespread gambling problem and the proliferation of rowdy saloons, news of this South Seattle whorehouse proved to be the final breaking point for the city's reformers, and a petition was soon introduced to recall Gill from office. Matthews made the anti-Gill petition available at his Sunday services while the WCTU hit the streets in an aggressive grassroots effort, energized by the campaign slogan "Ladies—Get Out and Hustle!" Even the local newspapers expressed outrage over Gill's activities, with the *Seattle Star* declaring, "The Star stands squarely against Hiram Gill and his policy of turning the city of Seattle over to be looted by the vice syndicate, to the uncounted cost in men's and women's souls." Within weeks, enough signatures were gathered and a recall election was held—the first of its kind in the entire country.

On February 7, 1911, local voters made clear that Gill was unfit to be mayor and he was subsequently ousted from office. Women, newly strengthened with the right to vote, were a deciding factor in the vote totals, and the forces of virtue were able to celebrate yet another important victory. The impact of Gill's sudden political demise was felt almost immediately. The next day, nearly two hundred gaudily dressed prostitutes were seen boarding a train out of Seattle, offering a stunning visual reminder that the days of the Gill administration were officially over. Within a month, it was estimated that more than half of the Tenderloin women had left town. Meanwhile, the incriminating evidence gathered by Matthews's detectives finally came to light, resulting in a grand jury investigation and the indictment of Wappenstein on corruption charges. Wappy was found guilty and sentenced to three years of hard labor, to be served at the Walla Walla State Prison.

An undeterred Gill returned to his law practice and quietly plotted a political comeback. To everyone's surprise, he ran for mayor again in the

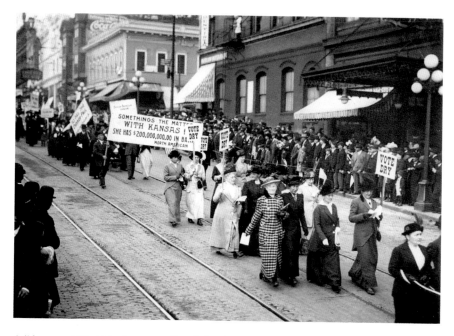

A "dry march" held in downtown Seattle by the Woman's Christian Temperance Union, 1915. *Courtesy of Washington State Historical Society.*

1912 elections though was predictably defeated by staunch prohibitionist and Anti-Saloon League leader George Cotterill. After assuming office, Cotterill remained active in the local chapter of the Anti-Saloon League and used his political influence to help gather the required number of signatures needed to put yet another important initiative on the state ballot. Washington Initiative Measure 3 was filed on January 8, 1914, and, if successful with state voters, would prohibit the manufacture and sale of alcohol statewide. With this initiative now on the upcoming state ballots, the local temperance movement went into overdrive. Well-known speakers were sent to every town in the state, registering dry voters and handing out large amounts of propaganda. Parades and rallies were held in an effort to drive up voter excitement. The Reverend Matthews was, of course, a huge proponent and used the power of his popular Presbyterian church to help sway public sentiment. Overall, the religious forces behind the initiative had successfully turned it into a moral referendum on small-town values versus big-city corruption. With the fate of their very businesses on the line, many of the state's breweries and saloons actively campaigned against the measure. The Seattle Brewing and Malting Company took out a full-

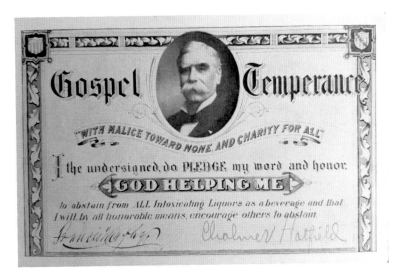

An abstinence pledge card from a local Seattle church, early 1900s. *Author's collection.*

page ad in local papers, encouraging voters to vote against the initiative. On November 3, 1914, state voters turned out in record numbers to decide on this important issue. After all the votes were tallied, Initiative Number 3 officially became law with 189,840 voters in favor of the measure and 171,208 voters against it.

The measure exposed a deep divide between urban and rural voters as it failed by a large margin in places like Seattle, Tacoma and Spokane, whereas rural voters, tired of the rowdy saloons that had overtaken their small towns, were overwhelmingly in favor. Thanks to the organizational achievements of local temperance groups, Washington had now joined twenty-three other states in voting to go dry. That same year, the Anti-Saloon League held its twentieth-anniversary convention in Columbus, Ohio, and announced its campaign to achieve national prohibition through a constitutional amendment.

In Seattle, the November elections in 1914 resulted in another improbable outcome. Hiram Gill, now running as a Closed Town candidate, was reelected as mayor. With state prohibition looming, Gill presented himself as a reformed man who now supported temperance and honest government. He vowed to enforce any new prohibition laws and clean up the vice problem that he had helped create. Only time would eventually reveal if Gill's platitudes were authentic or not.

WASHINGTON GOES DRY

The trouble is you ought to pay your fare over to the night conductor.
—Hiram Gill, from the 1917 court testimony of Logan Billingsley,
who reported this to be Gill's response when Billingsley approached the mayor
about needing protection for his whiskey operation

A s New Year's Eve celebrations reached their pinnacle and Seattle counted down the final minutes of 1915, local bartenders and saloon owners throughout the city began shouting out their last calls for drink orders. Effective midnight, Washington was to become a dry state and would remain so until 1933. This would be the area's last call for almost two decades. Just a few hours after the new law went into effect, Seattle police closed down a bar on First Avenue and arrested its two owners for illegally selling liquor. This would be the first of many such arrests in the years to come and was a startling paradigm shift for a city accustomed to years of such hard drinking and depravity.

With the new law in place, the sale and manufacture of alcohol was now illegal, though personal consumption was still permitted. Washington State residents were allowed to import up to either a half gallon of hard liquor, or a case of beer (twenty-four bottles), every twenty days. The alcohol had to be manufactured out of state, and a legal permit was needed from a county auditor. The demand for these was so great that the county auditor's office in Seattle issued over eighteen thousand permits in just one month. The new law also allowed one to obtain medicinal alcohol (usually whiskey) with a valid

prescription. In order to obtain a prescription, a person would need to visit a legal doctor's office and present the physician with an impairment or malady requiring such a script. Any garden variety ailment would typically suffice, and Seattle immediately saw a staggering rise in back pain complaints and sleep disorders. Once a prescription was obtained, the medicinal whiskey could then be picked up at the nearest neighborhood drugstore, just as if it were any other type of medicine. As a result, pharmacies suddenly became a desirable business opportunity for entrepreneurs looking to tap into this new market, and it was estimated that over sixty-five new drugstores opened in just the first three months of statewide prohibition alone. Along with new drugstores, there emerged a cottage industry of doctors eager to cash in on this new medical demand and who were quite willing to write out as many prescriptions as possible.

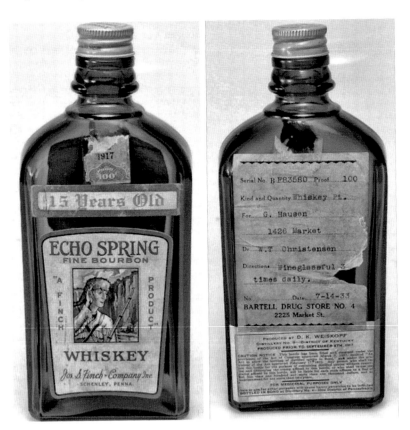

Medicinal liquor bottle from a Bartell Drug Store in the Ballard neighborhood of Seattle. *Courtesy of Bartell Drug Store Archives; photograph by Madeline Holden.*

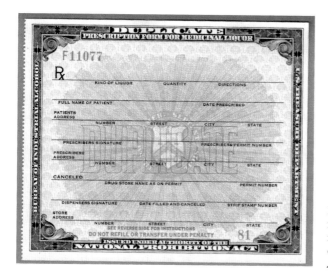

Liquor prescription form that was needed for medicinal alcohol during Prohibition. *Author's collection.*

Those without the means to obtain either a liquor permit or doctor's prescription resorted to other avenues. Illegal moonshine became one such option, though it certainly wasn't an appealing one as black market moonshiners often used cheap and inferior quality ingredients when making their product. Whatever scraps were on hand that would result in fermentation would often be used. This included anything from rotten fruit and potato peels to wood chips that were thrown into a mash and allowed to decompose, ferment and eventually become available for purchase on the street as "snake eye" or "rotgut." Even more dangerous was fake booze made with denatured rubbing alcohol. This risky concoction would be mixed with ingredients such as prune juice and creosote in order to obtain the right appearance and flavor, and then sold to unsuspecting customers as whiskey. This version would not only make people violently ill but often resulted in permanent blindness and even death.

If one wanted to avoid the risks associated with moonshine, "soft drink stands" became a popular and convenient option. Soon after the new law took effect, many local bars re-opened as soda shops. These innocuously disguised establishments would sell a variety of different flavored sodas, though hidden behind the counter and out of view of the police were more illicit beverage choices that could be added to the customer's drink for an additional fee. So popular were these stores that many people started calling soda shops the new saloons.

Over in city hall, Mayor Gill was anxious to prove that he was a reformed man who would be tough on crime and decided to lead a series of highly

publicized raids on various soda shops, restaurants and even some private social clubs. This included the Rainier Club, which was continuing to offer alcohol to its paid members. At the American Cafe, Gill's police squad put on a zealous display of prohibition enforcement, using long-handled axes to completely demolish the interior of the illegal drinking establishment. Other law enforcement officials joined in these efforts, including King County sheriff Bob Hodges. Hodges had previously run as a Republican candidate for governor in 1912 but was soundly defeated at the polls. He blamed his defeat on Seattle's elites, whom he believed had financed efforts against his candidacy, and decided to take revenge by raiding some of their homes and businesses. His first stop was the home of William E. Boeing, founder and president of Boeing Aircraft, in which several bottles of whiskey, three cases of beer and an entire wine cellar full of expensive wine were seized by the sheriff himself.

In May 1916, five months after the new law had gone into effect, Hiram Gill sent his police force over to the Stewart Street Pharmacy, owned by two brothers, Logan and Fred Billingsley. There had been widespread reports that their pharmacy was illegally selling bootlegged alcohol, and Gill wanted a public example to be made. Seattle police arrived just as the brothers were receiving a shipment of liquor, and the officers not only confiscated the illegal booze, but used axes and sledgehammers to completely demolish the interior of the store. With their pharmacy destroyed, the Billingsley brothers decided to abandon the brick-and-mortar model of business and instead enter the world of bootlegging.

The term *bootlegging* is believed to have originated during the Civil War when soldiers would sneak liquor into their camps by hiding bottles of it in their boots and next to their legs. Over time, bootlegging became a general term for smuggling alcohol on land—originally by horse and then later by automobile. Anything smuggled by boat or ship became known as rum-running. At this stage of prohibition, Idaho and Oregon had both voted to go dry as well, so smugglers ran booze up from California, usually by boat. Since booze was still legal in California, bootleggers would buy wholesale quantities of it in the Golden State and then hire ship owners to smuggle it up to drop-off points along the Washington coast. Those in charge of hauling the illicit cargo on their boats were the earliest versions of Pacific Northwest rumrunners. It proved to be a lucrative trade, though it was not without its risks. One such risk was the threat of piracy, particularly at the hands of the notorious Jack Marquett. Known as "Pirate Jack," Marquett and his crew of hijackers would

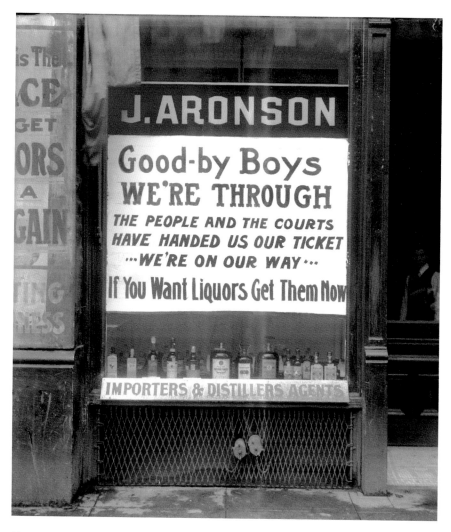

Sign in front of J. Aronson Liquor Store at the beginning of statewide prohibition in 1916. *Courtesy of Museum of History and Industry (MOHAI).*

hide in coves and inlets along the Western Seaboard, ready to relieve rumrunners of their precious cargos at gunpoint. After the ambush was complete, Marquett would then transfer the crates of booze onto his own ship and complete the mission to the Washington coast, where the pirated alcohol would eventually make its way to his headquarters in Seattle. So successful was Marquett's pirate operation that he single-handedly controlled the local black market for alcohol.

The Billingsley brothers, on the other hand, decided to procure booze by simply manufacturing their own. Setting up an illegal distillery in a downtown Seattle warehouse, the two brothers were soon pumping out ample quantities of quality moonshine to a thirsty public. Marquett naturally came to view the Billingsley brothers as a threat, and tensions between the two groups quickly developed, with each side making threats against the other. Fearing that Marquett would attempt an ambush, the Billingsleys hired an armed guard to keep watch over their warehouse. This was during a particularly tense time for the city as some recent labor strikes had turned decidedly violent. In response, the Seattle Police Department had more officers out patrolling the streets than normal. The night of July 24, 1916, found two of these patrolmen strolling past the Billingsley warehouse while out walking their assigned beat. The details of what happened next have never been fully resolved, but a gunfight broke out between the Billingsleys' security guard and the two officers. It is believed the guard simply caught a glimpse of the two cops as they walked by and, believing them to be Marquett's men, opened fire. When the smoke had finally cleared, the guard and one of the officers both lay dead from gunshot wounds. Even for a town as rough and tumble as Seattle, this was a stunning turn of events. The Billingsley brothers were immediately arrested, and the story of the shoot-out dominated the front pages of local newspapers for several weeks.

Watching everything unfold from the sidelines was fellow police officer Roy Olmstead, who had recently been promoted to lieutenant. Olmstead, who was a personal friend of Hiram Gill's, was not immune to accepting an occasional bribe himself. He carefully observed how these first generations of Seattle bootleggers were running their businesses. Noting both their mistakes as well as their successes, he studied how they organized themselves. He was involved in several liquor raids and considered many of the bootleggers to be unorganized and inefficient. To him, these bootleggers were inept men more comfortable with violence than running a successful business. Coming from a law enforcement perspective, Olmstead mentally entertained how one could make maximum profit by running such a smuggling operation. Within months of the warehouse shooting, Jack Marquett was arrested on corruption charges and Olmstead saw a window of opportunity open up. He soon became part owner of a small business called Shipyard Service Station that sold gas, oil and boating accessories on a busy Seattle wharf. On certain nights, and under the cover of darkness, the business would also buy and sell other goods.

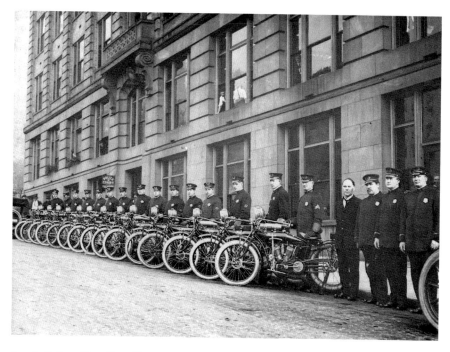

Seattle Police officer Roy Olmstead, with the department's motorcycle squad, October 22, 1914. *Courtesy of Museum of History and Industry (MOHAI).*

Being the opportunist that he was, Hiram Gill used the Billingsley incident to his own political advantage. While out campaigning for the upcoming mayor's race, Gill played up the Billingsleys' arrest as testimony to his toughness on crime. The strategy worked, and Gill saw himself elected mayor for a third time in the 1916 elections. Despite publically promoting himself as a law-and-order type, behind the scenes Gill was back to his old tricks of accepting payoff money from the local vice syndicate. Before long, Seattle was back to being an "Open Town," gaining such a wild reputation that the local army base, Fort Lewis, declared the entire city off-limits to its soldiers after too many of them were taken out of service due to venereal disease. At the same time, the Billingsleys' trial was underway, where it was implicated that Gill had accepted payoff money from the two brothers. Other underworld types also stepped forward with similar claims, and once again a full-blown Hiram Gill scandal was making headlines in all the Seattle newspapers. In January 1918, Gill was disbarred from the legal profession due to the ongoing ethical problems that had plagued his career. Despite his public approval rating taking a dramatic nosedive, Gill somehow managed to remain in office while Seattle teetered

toward outright lawlessness. Presumptuously, Gill ran for reelection that year but couldn't escape all his many controversies and was soundly defeated at the polls. The winning candidate was a strict prohibitionist by the name of Ole "Holy" Hanson. Seattle was hungry to have some law and order restored, and Holy Hanson was now the new mayor. Hiram Gill unceremoniously died a few months later, on January 7, 1919. He was fifty-three years old.

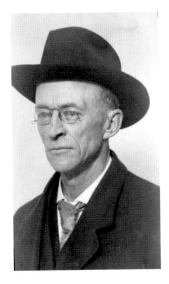

Seattle mayor Hiram Gill in 1916. *Author's collection.*

On a national level, the forces of prohibition were hard at work. The Anti-Saloon League, buoyed by its widespread success in several states, focused its efforts at the federal level and began a widespread campaign to implement national prohibition. The league started with heavy lobbying efforts, and even presented the U.S. Congress with a draft of the Eighteenth Amendment. The league, at this point, boasted a nationwide membership in the tens of thousands and used the "strength in numbers" strategy to inundate Congress with letters, petitions and even threats. What started as a small grassroots movement had grown into a powerful force with a strong national influence. Political representatives wanting to remain in office felt pressured to align themselves with the temperance movement and cast their votes accordingly. The Anti-Saloon League was also able to take advantage of the anti-German sentiment left over from World War I to successfully demonize the beer industry, as many of the breweries were owned by those of German descent. With the anti-alcohol sentiment of the country growing at large, Congress passed the Eighteenth Amendment on January 16, 1919. The amendment prohibited the manufacture, sale, transportation and possession of alcohol. The law was ratified by the required two-thirds majority of the states in 1919, effectively making it law. A short time later, the Volstead Act (otherwise known as the National Prohibition Act), which established the legal means for the federal government to enforce the Eighteenth Amendment, was enacted. This new federal law was a lot stricter than Washington State prohibition had ever been and was set to take effect on January 17, 1920. With the Eighteenth Amendment now in effect, and Hiram Gill laid to rest at the Evergreen Washalli Cemetery, Seattle was about to enter an exciting new chapter in the Prohibition saga.

THE BOOTLEGGERS

The whiskey comes here in a boxcar;
The brandy comes over the sea;
The gin cometh in an airplane—
So shake up a cocktail for me.
—local anthem popular during Prohibition

I n the late night hours of March 20, 1920, an unassuming boat slowly approached Meadowdale Beach—a quiet and lightly inhabited waterfront area just north of Seattle. One of the men on the boat blinked the ship's spotlight a few times and waited for a response. From the beach, a flashlight blinked back. With this go-ahead, the boat pulled up to a small wooden dock and exchanged greetings with a crew of bootleggers who had been waiting for the delivery. This was to be a swift operation and, within minutes, crates of alcohol were being unloaded from the boat and into waiting cars. As the last of the booze was being handed off, the entire area suddenly became lit up with floodlights and police sirens. Figures swiftly emerged from the darkness of the surrounding woods, and the smugglers unexpectedly found themselves surrounded by a mix of federal Prohibition agents and local police. Some tried running but were promptly stopped when police drew their guns and opened fire. The authorities had been staking out this known smuggling spot for several weeks, and it was now looking like their long hours of hard work were finally paying off as this usually quiet stretch of beachfront erupted into a wild scene of flashing lights, loud shouting, violent

arrests and random gunfire. Surreptitiously taking advantage of the ensuing chaos, one of the bootleggers quietly slipped into his own car, started the ignition and hit the gas, roaring past a police barricade farther up the road. Orders were shouted for the vehicle to stop and shots were fired, but the car managed a deft escape from one of the largest seizures of booze in the Pacific Northwest.

Unfortunately for the driver, he was recognized by one of the officers stationed at the barricade and the next morning Seattle police arrived at his house and placed him under arrest. It was a shocking turn of events given that the man himself was a prominent member of the Seattle Police Department. He was immediately dismissed from the force and later released on bail. With a family to feed, the now unemployed man surveyed his options and, well aware of the potential profits to be made in the world of bootlegging, decided to pursue it as a full-time career. Within months, he used his inside knowledge of the business to establish himself as king of the Seattle bootleggers. Some in the press would later nickname him "The Gentleman Bootlegger," given his disdain for violence and the ethical way he ran his business, but to most he was simply known by his birth name, Roy Olmstead.

In a South Seattle neighborhood colloquially known as "Garlic Gulch" due to its large Italian population, a souped-up sedan with a loud and powerful engine sped down one of the residential streets. In the passenger seat sat Frank Gatt next to his trusted driver, Nick the Greek. They had just picked up a shipment of alcohol from one of Frank's moonshine operations, which they then dropped off at the Monte Carlo, a downtown "soda shop" that he also owned.

When Prohibition hit, Gatt was a successful saloon owner who now found himself in the predicament of needing to choose a new profession. He decided to remain in the beverage industry, though would now be operating under a decidedly different business model. His new operation was to be two-fold. First, he would be making his own moonshine. He was familiar enough with alcohol production to confidently set up his own distilling operation, and unlike the unpalatable rotgut typically sold on the street, Gatt wanted to make quality shine that would taste just as good as any top-shelf booze. To do this, he built a series of large-scale moonshine stills that basically served as professional distilleries. He used only top-quality ingredients for the mash, which was then distilled using professional-grade equipment. The majority of his stills were made of copper due to its superior heat conducting qualities and the fact that it

didn't alter the taste. He was also very selective when it came to who ran his stills. His crews needed to be adept at the entire process: from cooking the mash and using the perfect ratios of hand-ground corn, sugar and malt; to maintaining the perfect temperature during the distillation stage. No corners were ever to be cut. The result was a reliably safe and tasty product that was never mistaken for the bathtub variety sold on the streets.

The second part of his operation consisted of a series of restaurants and soda shops he owned and which were to be used as fronts to sell his hooch. At the Lakeview Inn, famous for its chicken dinners, many of his customers would enjoy a full meal then purchase a bottle of Gatt's moonshine on their way out the door. At the Monte Carlo, people would enjoy special "sodas" while shooting pool on the fancy billiard tables inside. The booze itself was always kept hidden in secret compartments behind the grand mahogany bar, in case law enforcement ever decided to pay a visit. Gatt's establishments were the only places to buy his hooch, thereby avoiding any risky street deliveries.

His business model proved to be a financial success, and he soon rose up to become a popular and respected figure throughout his South Seattle community. He was flashy—often attired in pinstripe suits and with a rolled up wad of cash in his hands—but was also philanthropic, frequently offering financial help to those in need. Among his close friends was Asahel Curtis, a prominent local photographer. Asahel was known for his stunning photographs of the Seattle cityscape and was the younger brother of Edward Curtis, who was becoming famous for his lifetime project of photographing the last of the North American Indian tribes before their traditional cultures vanished into twentieth-century modernity. Frank's nickname for Asahel was "Ace." That a photographer and bootlegger would be such close friends might have seemed like an odd pairing, but Asahel was a frequent visitor at the Gatt household. On this day, though, there would be no visits from any of Frank's friends. One of his moonshine stills had recently been raided and shut down by the local sheriff, so he needed to scout out better locations that would be harder to find. After completing their daily deliveries, Frank and Nick loaded themselves back into the custom-built hot rod and sped off to survey possible sites up in the rural farmlands of North Seattle.

The Eighteenth Amendment prohibited the production, sale and transportation of alcohol, though it did not specify what the penalties would be if the law were violated. Wayne Wheeler, national leader of the Anti-Saloon League, took notice of this and drafted the Volstead Act, which laid out exactly how the Eighteenth Amendment would be enforced. It also

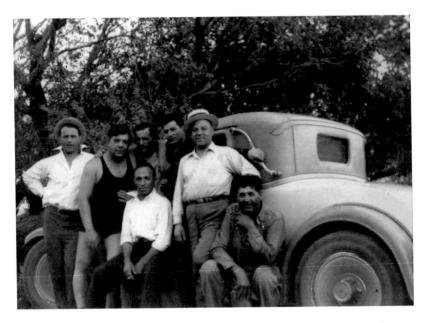

Frank Gatt and his crew standing in front of his Franklin sedan after a day at the beach. 1920s. *Courtesy of Jewelli Delay.*

introduced the new agency tasked with enforcing it: the Bureau of Prohibition. The Volstead Act was initially vetoed by President Woodrow Wilson, but his veto was overridden by the both the House and Senate, thereby enacting it into law on October 27, 1919. Enforcement of the Volstead Act was to officially begin in early 1920. This gave relatively little time for the Treasury Department, tasked with running this new agency, to have it in operational order by its early winter roll-out. Quick work was therefore essential.

It was decided that the Bureau of Prohibition would have offices and agents in every state, and that each state would have its own director. Roy Lyle was selected as the federal Prohibition director for Washington. To some, the thirty-eight-year-old Lyle was a surprise choice given that he was widely dismissed as a milquetoast with very little experience in government work and did not even possess a college degree. However, he was acting secretary of the influential Seattle Young Men's Republican Club, whose roster included several key members of the local Anti-Saloon League. At the time, many believed that these important connections are what earned him the appointment. Lyle soon choose William Whitney as his assistant Prohibition director. Rumors at the time held that Whitney was originally intended to be director, but was passed over due a scandal involving a married woman.

True to his timid reputation, Lyle preferred to remain behind the scenes, tending to the administrative duties of the job and leaving management of the Prohibition agents to Whitney. Because of this arrangement, Whitney would eventually emerge as the known enforcer and de facto leader of the local Prohibition office. He wanted a strong team of tough-minded agents working for him and went about selecting men known for their brutish character. Under Whitney's leadership, aggressive and violent tactics were encouraged if that's what got results.

While Whitney was building his team of agents, Frank Gatt was busy setting up a new still at a dairy farm. Realizing that the strong smells and odors created during the moonshine process were attracting the unwanted attention of law enforcement, Gatt came up with the brilliant idea of operating his stills out of rural dairy farms. This way, the strong cattle smell would offset any distillation odors created by the moonshine process. Most of the farms were also remote and far off the beaten path of any nosey deputies. Gatt's first purchase was the Nelson Dairy Farm, located two

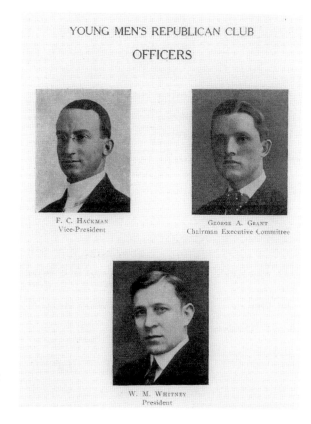

YOUNG MEN'S REPUBLICAN CLUB

OFFICERS

F. C. HACKMAN
Vice-President

GEORGE A. GRANT
Chairman Executive Committee

W. M. WHITNEY
President

Seattle Young Men's Republican Club from 1915. William Whitney served as the president of the club. This is the earliest known photo of Whitney. *Author's collection.*

miles north of Seattle's Green Lake, where he set up a giant still in one of the farm's inconspicuous-looking barns. To further add to the illusion that nothing illegal was taking place, the Nelson family continued to live and work at the small, humble farm, operating their dairy business as usual. To anyone passing by, nothing would look unusual or out-of-place. Gatt's moonshine crews soon began operating two massive stills on the property, the largest of its kind in the entire Pacific Northwest. Each of the stills had a five-hundred-gallon capacity, with enormous-sized vats to store the liquor after it was made. The booze would then be bottled and loaded into one of Frank's cars and driven under the darkness of night to his various restaurants in downtown Seattle. His preferred delivery vehicle was a Franklin two-door sedan which boasted an air-cooled V-12 engine. Gatt had even added a bullet-proof exterior to the car, in the event of any unplanned encounters with Prohibition agents. Nick Plakonicus (aka Nick the Greek), one of Gatt's most trusted men, was typically the driver in these late-night deliveries. Like in many parts of the country, Prohibition was extremely unpopular in Seattle, and sightings of Frank and Nick driving around in their souped-up hot rod quickly became celebrated as a popular and recognizable symbol of this local anti-Prohibition sentiment.

For many local bootleggers, neighboring Canada had emerged as the top supplier of alcohol. Canada had its own period of prohibition during the First World War, but this wartime law was repealed in 1919 just as the Eighteenth Amendment was being passed here in the States. As a result, nearby British Columbia became a popular vacation destination for dry Washington tourists, who would purchase booze in places like Victoria or Vancouver and then sneak it back with them to the United States. This had become risky though, as anyone caught doing so could now be charged under the Volstead Act. Likewise, professional smugglers began obtaining their liquor at wholesale prices through special Canadian export houses in British Columbia. Sometimes these export houses would deliver large, prearranged shipments of booze to various island drop-off points located in the Canadian territorial waters of the Haro Strait. The islands typically used included Discovery, Saturna or D'Arcy Island, all of which belong to a larger islet chain shared between the two countries, including the San Juan Islands on the American side. These liquor shipments would then be loaded up by American rumrunners who would smuggle the alcohol back to the United States in powerful speedboats. In short order, these foreign export houses were making a fortune from Pacific Northwest bootleggers and, most importantly, were

not violating any Canadian laws by doing so, as there was nothing on the books which prohibited them from selling to other countries.

Among the growing community of local rumrunners was a native Washingtonian who grew up fishing and hunting in his boyhood town of Chehalis. As a young man, he worked for a local logging company before enlisting in the U.S. Army to serve during World War I. After the war, he took a job at a Canadian boathouse where he began meeting some of these early rumrunners and was eventually presented with a lucrative offer to help out on a ship running booze down to San Francisco. Johnny Schnarr knew this to be in violation of the Prohibition laws but, having such an adventurous spirit, he accepted the job anyway. The subsequent journey turned out to be a disastrous failure and, for the average person, probably would have ended such aspirations right then and there. But Schnarr was no average person and the experience, as bad as it was, simply served as his entry point into the wild, uncharted world of Pacific Northwest rum-running. Within a few years, he was so successful in this new venture that the U.S. Coast Guard offered a reward for his capture.

Throughout Western Washington, which had always been considered the "wet" side of the state, Prohibition remained wildly unpopular, though, by now, most people had figured out various ways to obtain alcohol. Those without the means to purchase expensive bootlegged alcohol simply made their own. Most corner grocery stores sold items that were known for making moonshine and home-brewed beer, such as bottles, stoppers, malt and hops. Another popular item sold at grocery stores was the "wine brick," which was simply a brick of concentrated grape juice that, if dissolved in water and allowed to ferment, would turn into wine. Instructions for this process were usually printed on the wine bricks in the guise of an official warning of what "not" to do with the product. Several local breweries managed to stay in business during Prohibition by selling malt syrup. All one needed to do was add some yeast to the malt concoction and, after a week or so, a potent batch of home-brewed beer would be ready to drink.

Speakeasies were also beginning to emerge. Some resembled the traditional style of speakeasy, as depicted in movies, where a secret password was needed in order to gain entrance past a locked door. At the fabled Bucket of Blood, customers arriving at the clandestine Seattle location would need to knock on a heavy steel door and present a special membership card through a narrow window slit. Once the card was validated, the door would be opened and the customers allowed in. From there, they would descend down a muraled stairway and into an ornate basement club area that was always

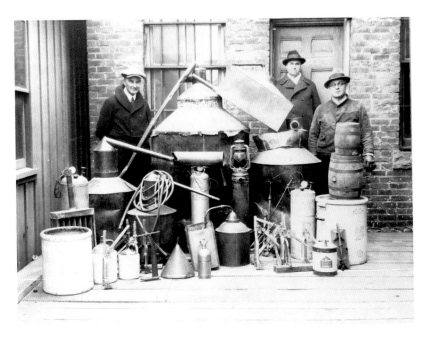

Pacific Northwest moonshiners posing next to their still in the 1920s. *Author's collection.*

packed with excited partygoers. The Bucket of Blood's real name was the Hong Kong Chinese Society, but it was given its nickname due to the large tin cups that beer was served in. Servers would walk around with trays of drinks, while fashionably dressed patrons danced to live jazz. Local legend holds that one of the female servers at the Bucket of Blood was a woman by the name of Lucille Jeter, who would later give birth to famous guitarist Jimi Hendrix. However, some hold that in dispute given the purported year of her birth. Local papers would later describe the place as "Seattle's most colorful, flourishing and fashionable nightclub."

Other speakeasies simply disguised themselves as restaurants, while others acted as gambling halls where members would wear special lapel buttons designating if they were there to gamble, drink or both. Several houseboats on Seattle's Lake Union were also known to have served as secret liquor clubs.

One of Olmstead's top customers at the time was a light-skinned black man by the name of John Henry "Doc" Hamilton, who operated his first speakeasy in Seattle's Central District neighborhood. At the time, the Central District was the nucleus of Seattle's African American community,

with many black-owned businesses. Hamilton's speakeasy was quickly closed down by police, but he would later open his popular drinking establishment Doc Hamilton's Barbecue Pit. Despite the name, it was a fancy dinner club with an elegant and stylish interior that many have since compared to Harlem's Cotton Club. Guests would pull up to the front and be greeted by a well-dressed doorman who would escort them to their table. Once inside, Doc Hamilton would walk around and personally introduce himself to all visitors. The Barbecue Pit was always well-stocked with top-shelf booze, courtesy of Olmstead's bootlegging operation, and offered a variety of delicious barbecued meats. It also served as one of the top venues for local jazz bands, so it was regarded by many as one of the city's best music spots. In the event of an unplanned raid, Hamilton had installed a special alarm system that allow guests the opportunity to escape. Hamilton's speakeasy soon became the favorite watering hole of Seattle's business and political elite, with many important meetings held inside. The status of his clientele certainly helped keep his business from being shut down, and the Pit remained one of the city's top speakeasies throughout most of Prohibition.

North of the city, along the main thoroughfares such as Lake City Way and the Pacific Highway (Highway 99), roadhouses and speakeasies also became prevalent. These operated safely outside of Seattle police jurisdiction and were far enough away from local Prohibition officials that raids were relatively uncommon. One of the most fabled of these was the location eventually known as the pirate-themed roadhouse, the Jolly Roger. Starting out as the Chinese Castle, the building boasted a two-story watchtower where spotters would be posted to watch for incoming police vehicles. When a raid took place, those in the watchtower would sound the alarm, giving plenty of time for partygoers in the basement club area to flee through an escape tunnel which led them to safety and freedom across the street. Another well-known establishment was the Ranch Roadhouse on Highway 99. Located in Edmonds, the Ranch served as a restaurant and dance club where guests could enjoy illegal spirits as they danced the night away. As with many of these north-of-the-city roadhouses, the Ranch always kept its bar well-stocked thanks to Roy Olmstead. Doc Hamilton even operated a roadhouse on Highway 99 simply called the Pit.

With the 1922 elections right around the corner, Seattle mayoral candidate Edwin "Doc" Brown was openly campaigning as an anti-Prohibitionist. The sixty-year-old ex-dentist, known for his youthful energy that was accentuated by a head full of thick, dark hair, was very vocal about his opposition to the Eighteenth Amendment. Surprisingly, Brown did not personally imbibe in

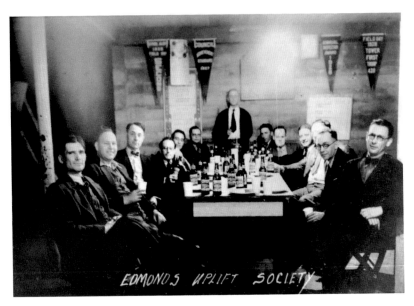

The Edmonds Uplift Society, a secret drinking club that enjoyed copious amounts of Rainier beer during Prohibition. *Courtesy of Edmonds Historical Society.*

alcohol but felt that it was the public's right to do so. He was diametrically opposed to what he felt was the oppressive nature of Prohibition laws and openly called for the amendment's repeal. During speeches, he was known for his eloquence on this matter, telling voters, "I'm for temperance now, temperance in eating, in drinking, in religion, in all things. Temperance, that beautiful word, not prohibition—tyrannical, unreasonable, without meaning, making thousands of criminals." Before exiting the stage to the accompaniment of a live jazz band, he would excite his crowds of supporters by promising, "No one is going to die for want of a drink of good spirits as long as I'm mayor!"

Meanwhile, Roy Olmstead had aggressively grown his operation to become the area's top bootlegger. At this point, he was sending his speedboat, the *Zambesie*, on regular runs to Haro Strait to pick up prearranged shipments of Canadian booze at D'Arcy Island. This particular island was strategically chosen by Olmstead as it was surrounded by dangerous reefs and was also the site of a leper colony. Because of this, visits by unwanted guests were a rare occurrence. He had even made financial arrangements with the leper keeper to serve as a lookout, and before long the island was serving as his official Canadian pickup point. After the ship was loaded up with booze, his crew would then wait until evening, just as the sun was setting, for the

perilous voyage back to Puget Sound. To help minimize the risks of being caught by the Coast Guard, Olmstead had spotters in strategic locations such as Port Angeles and Port Townsend. If a rumrunner received an "all clear" from the spotters, he would then speed down to various docks throughout Tacoma, Seattle and Everett.

From there, the booze would be loaded into waiting delivery trucks and brought to temporary holding spots, usually parking garages and warehouses, to await delivery to the city's speakeasies, soda shops and private social clubs. Olmstead paid off police officers on harbor boats and patrol cars to serve as lookouts for his operation. All his years spent on the force gave him an intimate knowledge how the Seattle Police Department operated. He knew their schedules and procedures, as well as who could be paid off and who couldn't. As a result, a large majority of the city's police force had its bank accounts padded thanks to Olmstead. In fact, the running joke at the time was that Olmstead commanded more officers as a bootlegger than he ever did as a police officer. This proved to be a frustrating experience for federal Prohibition agents, though, as they could never quite get close enough to ever observe his operations much less ever catch him in the act.

Further establishing himself as a savvy and brilliant businessman, Olmstead figured out a way to avoid paying Canadian export duty tax on his liquor, which allowed him to sell his alcohol at prices significantly cheaper than his competitors. To do this, he took advantage of a trade agreement between Canada and Mexico. The Canadian government had eventually become wise to the staggering number of alcohol shipments going to the thirsty American market, which, to them, represented a potentially large sum of missed tax revenue. As a result, Canada imposed an export tariff of $20 per case for all American-bound shipments of alcohol. Olmstead exploited this by hiring cargo ships in Vancouver and loading them with large amounts of alcohol, sometimes up to four thousand cases. He would then have the documents falsified or forged to make it look like the ships were bound for Mexico, thereby avoiding this $20-per-case duty tax. This enabled him to undercut his competitors by as much as 30 percent and establish his dominance in the local market. He was soon smuggling two hundred cases of liquor per day, and earning $200,000 per month. This was a huge sum of money in the early 1920s, especially compared to his previous salary as a police officer. Before long, Olmstead could be seen driving around in luxurious cars while dressed in dapper suits. He purchased a palatial estate in the Mount Baker neighborhood where he threw some of the most lavish

parties in the city. If he was now being crowned the "king of the bootleggers," he figured he might as well look the part.

As was predicted, Doc Brown won the 1922 Seattle mayoral race in a landslide victory. Immediately upon assuming office, Brown let it be known that if the federal government wanted Prohibition enforced then federal agents should enforce it themselves. He also believed that imported alcohol was safer than street-level moonshine and ordered his police force to concentrate on people selling "bad booze" rather than harass any of the bootleggers. In fact, he was quite cozy with some of the local underworld, including Frank Gatt, whom he considered a close friend.

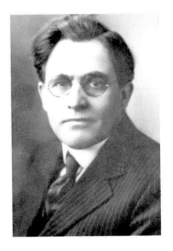

Seattle mayor Edwin "Doc" Brown. *Courtesy of Seattle Municipal Archives.*

There was even an unsubstantiated rumor that Gatt was running a still in the basement of Brown's home. Naturally, none of this earned him the endearment of William Whitney, and the relationship between the two men would eventually deteriorate into one of outright hostility.

Adding to this was Brown's permissiveness toward Roy Olmstead, who was quickly becoming famous as the "Gentleman Bootlegger" due to the ethical ways in which he conducted his business. Olmstead's number one rule was that his men would not carry guns or engage in any manner of violence. He believed that guns invited problems that could just as easily be solved by paying people off. Number two, his men would act and treat others with respect. He was running a professional operation and would not tolerate any thuggish or boorish behavior from any of his employees. Number three, he would not be involved in any prostitution, gambling or narcotics. Despite Prohibition laws, bootlegging was widely viewed as a respectable profession and he strove to keep his business within such limits. Lastly, he would sell only premium bonded liquor from Canada. Nothing inferior or watered down, nor would he sell anything stolen or hijacked. If you bought your alcohol from Olmstead, you knew you were getting the best stuff available on the market. As a result, all of Seattle's elite private clubs stocked his booze, including the Rainier Club, the Arctic Club and the Butler Hotel. The top speakeasies also purchased from Olmstead, including Doc Hamilton's Pit. The local press loved him, as did the citizens of Seattle. For many, Olmstead represented a safe way of obtaining good quality

alcohol that wasn't tainted by other criminal activity. As a person, he was friendly, approachable and had a great sense of humor. He was a common fixture on downtown streets, always willing to pose for a photograph or share a lighthearted conversation. On any given day, he could be seen talking to people from all walks of life, from a lowly street sweeper to the Reverend Mark Matthews himself. His business empire had grown to the point that he had become the area's largest employer, with a massive local workforce of clerks, drivers, swampers, dispatchers, mechanics, warehousemen and legal advisors. He was Seattle's "good" bootlegger, and people throughout the city adored him.

Soon after Brown was elected to office, a large crowd gathered near the shores of Seattle's Lake Union to witness the demonstration of a wondrous, new technology. A seventeen-year-old local prodigy by the name of Al Hubbard, whom many were comparing to Thomas Edison, had reportedly developed a generator powered by nothing more than the earth's magnetic field. Hubbard had been raised on Hood Canal and, despite only having an eighth-grade education, was considered a bona fide genius. His other inventions were said to have included a portable X-ray machine and a device that allowed blind people to see. On this day, Hubbard stood before the crowd and introduced a powerboat which, he explained, would be propelled by a magnetically charged engine. He named this new device the Hubbard Energy Transformer. It would later be theorized that Hubbard's motor was actually an early nuclear device powered by radium. This was during an era that such innovative new technology was transforming the world at a breakneck speed so, to the people gathered, all that mattered was that they were about to witness the introduction of an exciting new invention. After concluding his speech, Hubbard then proceeded to pilot the boat up and down the lake to the astonished delight of the crowd. The next day, the event was excitedly covered by all the local newspapers and quickly became the talk of the town. Despite all the publicity, Hubbard was virtually penniless and living with his young wife in a cramped University District apartment that also served as his work space.

In a serendipitous encounter, the young inventor happened to meet Olmstead, who was fascinated by Hubbard's obvious talent for mechanics, electronics and technology. During their conversation, Hubbard mentioned that he wanted to build a radio tower, which certainly caught Olmstead's attention as he had been toying with the same idea. The bootlegger offered to move the Hubbards into his spacious Mount Baker home, which they graciously accepted. Before long, the young couple was living in the basement

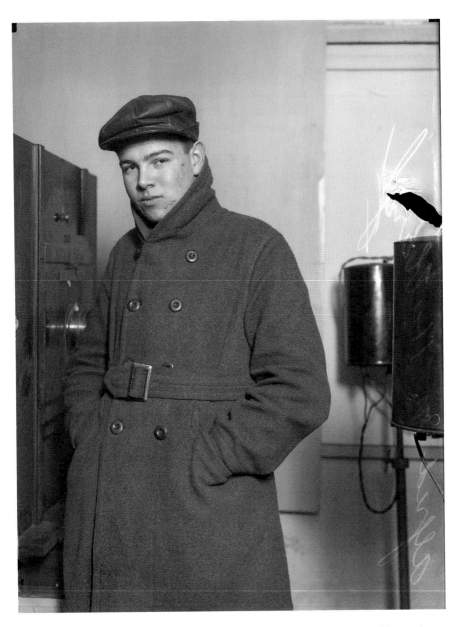

Al Hubbard in 1924, the year that he built Seattle's first radio station for Roy Olmstead. *Courtesy of Museum of History and Industry (MOHAI).*

of Olmstead's luxurious home, which Hubbard immediately transformed into his own laboratory. The focus of his efforts at the time involved building a radio tower, such as the one he had described to Olmstead and which would eventually serve as Seattle's first radio station.

Despite Olmstead's dominance, there were plenty of other bootleggers active throughout Western Washington. Compared to their East Coast counterparts, these Pacific Northwest bootleggers tended to be a civil and nonviolent lot. There were no violent gang wars or bloody massacres like what was happening in Chicago and New York. Rather than use guns or violence, local bootleggers were more inclined to rely on their business savvy to stay competitive. Perhaps this was a trickledown effect from the way Olmstead ran his business, or maybe it was the laid-back culture of the West Coast in comparison to the other side of the country. Whatever the reason, the only incidents of Prohibition-related violence were usually at the hands of the federal dry agents, who were known for their brutality. Most of the towns north and south of Seattle were typically controlled by one or two bootleggers, and down in Tacoma the top trafficker of booze was Pete Marinoff. Everyone knew him as "Legitimate Pete" due to the fact that he stuck to bootlegging and avoided all other criminal enterprises. With dark European features and a slight accent to match, Marinoff had an impressive fleet of seven speedboats he used for rum-running and was considered one of the shrewdest bootleggers in the Puget Sound.

The liquor trade throughout Western Washington was so robust, in fact, that Seattle actually hosted a bootlegger's convention in March 1922. Over a hundred bootleggers attended the event at a downtown hotel in which they formally established a set of rules and protocols for their illicit profession. Among the agreements was the price range for smuggled alcohol and the condemnation of any narcotics. As the lively and raucous convention came to a close, many of the bootleggers raised their mugs of beer and joined together to chant a popular ballad which perfectly celebrated the current state of Prohibition in the Pacific Northwest:

Four and twenty Yankees, feeling very dry,
Went across the border to get a drink of rye.
When the rye was opened, the Yanks began to sing,
"God bless America, but God save the King!"

THE RUMRUNNERS

Booze ships are bad places for decent sailor men.
—*Seattle judge John Partridge, 1924*

Johnny Schnarr was jolted awake by the sharp crash of his boat hitting a jagged sea stack off the Oregon coast. He raced up to the deck to find his partner fumbling at the wheel, desperately trying to steer them away from the imminent danger of the stormy coastline. Cursing under his breath, Schnarr grabbed control of the boat but only managed to maneuver it closer to the rocky beach. The waves began mercilessly crashing down on them, so the two men had no choice but to jump ship and struggle to shore. After collapsing on the beach, they watched as the ocean surf slowly started pounding their boat to pieces. Schnarr realized that they might have a chance to salvage some of their valuable cargo, so, between waves, the two men waded out and began the grueling process of hauling heavy sacks of booze from the boat to the safety of the beach. It was an exhausting affair, but they somehow managed to rescue the majority of their illicit freight. Sitting down in the sand and watching as the angry sea claimed the last remnants of their boat, Schnarr wondered how he ever got himself in this predicament.

Three days prior, Schnarr and his boating partner, Harry Schaefer, were pulling away from a dock in Victoria, British Columbia, with the cargo hold of their boat loaded full of premium Canadian rum. Schaefer had offered Schnarr $500 to help him deliver the shipment down to a bootlegging

operation in San Francisco. Assuming that Schaefer was an experienced sailor, and always looking for a little adventure, Schnarr eagerly signed on. He had spent a considerable amount of time on Washington fishing boats so was quite comfortable out in the open waters of the Pacific Ocean. A day after leaving Victoria, however, he discovered the unfortunate truth about Schaefer's actual seafaring experience. Up to this point, Schnarr had been piloting the boat for almost twenty-four hours, so he asked Schaefer to take the wheel for a bit while he caught a nap down below. A few hours later, he woke up and could immediately sense that the winds were blowing in the opposite direction from when he had lain down. He knew something was definitely off. Climbing up to the deck, he discovered Schaefer fumbling around and looking confused. It was obvious that he didn't know what he was doing. Retaking control of the vessel and eventually getting his bearings straight, Schnarr was shocked to discover that Schaefer had somehow turned the boat completely around and was steering them back toward Victoria. "You damn fool," Schnarr shouted at Schaefer, "you've completely turned us around!" It was at this point that Schaefer broke down and finally confessed his complete lack of any boating experience, admitting the whole thing was merely his attempt to get rich in the rum-running business. From there, things only got worse. At one point the ship's motor stopped working, though Schnarr was eventually able to make a repair. They then got stuck on a sandbar outside of Astoria and had to wait for the incoming tide to float them back out to sea. Two days later, and after being awake for several days with no sleep, Schnarr risked taking another nap, which is how the two men now found themselves stranded on this south Oregon beach. After resting for a bit and regaining some energy, they decided to walk to a nearby lighthouse for some help. Upon their return, they discovered that someone had stolen their entire stash of rum. They were now stranded on a desolate Oregon beach with no boat, no booze, no money and no way home. They eventually found a way to the nearest town and soon parted ways for good. Schnarr would successfully remain in the rum-running business but, from that point forward, would never rely on anyone but himself to get the job done.

Rum-running was nothing new in the Pacific Northwest. Over the years, local ships had smuggled everything from sugar to opium and now, under Prohibition, booze was the popular new cargo. This sudden demand for smuggled Canadian alcohol opened up unlimited job opportunities for those willing to take such risks, and it didn't take long for word to spread about the easy money to be made in the rum-running business. The financial

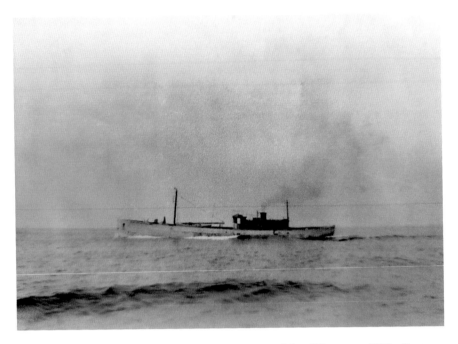

Canadian rum-running ship making a delivery for Consolidated Exporters, 1920s. *Courtesy of Coast Guard Museum Northwest.*

rewards for such endeavors were fairly high, and it was a relatively easy profession to get into. All one needed was a speedy boat, enough money to buy a load of Canadian booze and the courage necessary to smuggle it back into the United States. As a result, the new profession tended to draw skilled boatmen, particularly those with thrill-seeking tendencies and who were looking to make some extra money.

In the early days of Prohibition, the risks of being caught were relatively low as the American government simply didn't have the money or resources to properly crack down on all the illegal smuggling taking place. On land, enforcement belonged to federal Prohibition agents and local police. Out on the waters of Puget Sound, however, enforcement fell upon a small, ragtag fleet of outdated Coast Guard ships. This made capture easy to avoid for anyone with a fast enough boat and a savvy knowledge of the area's hidden inlets and waterways. The majority of rumrunners at the time were small-time men dealing with meager amounts of liquor. Most operated as independent contractors, fulfilling orders for wealthy customers. Others were part of larger bootlegging crews, such as Olmstead's operation. With so many men attempting to join this new

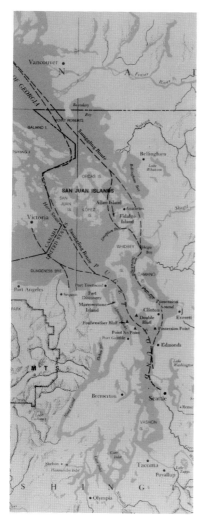

1920s map of Puget Sound showing routes used by rumrunners. *Courtesy of Coast Guard Museum Northwest.*

industry, competition became fierce. As a result, rumrunners were typically a wary, tight-lipped bunch, careful not to reveal their secrets to others. The competitive nature of rum-running was also reflected in the constant need for more powerful vessels, as those with the fastest boats were less likely to be caught and those with bigger boats were more likely to be hired for large orders. The local smuggling industry quickly became a constant game of one-upmanship and backstabbing, where rivalries were intense, trust was rare and friendships were few and far between.

Fueling all this was a huge surplus of leftover aircraft from World War I, most of which could be purchased anonymously and on the cheap. Local smugglers needed fast boats to outrun the Coast Guard so, being a resourceful lot, they began using leftover airplane engines to power their boats, most commonly the powerful V-12 engines used by Liberty combat planes. These smuggling ships powered by airplane engines soon became known as "fire boats," due to their speed and the fact that their hulls were full of "firewater." Boeing Aircraft had taken a direct financial hit due to its huge surplus of leftover aircraft from the war and was looking for creative ways to stay afloat as a company. Taking notice of the new demand for high-speed boats, Boeing introduced a line of quick, square-bowed boats with inverted hulls, called the Sea Sled. In 1923, Boeing advertised the sale of a dozen Sea Sleds in a Sunday edition of the *Seattle Post-Intelligencer*. Targeting a very specific demographic, the ad placed emphasis on the boat's speed. By the next day, every single Sea Sled had been sold and all had been paid for with cash.

Things were a bit tamer for Canadian rumrunners, many of whom worked for the export houses. Hauling booze down to the Haro Strait to rendezvous with their American counterparts became a desirable job as the trip there and back only took a few hours and they could earn as much as $1,000 per trip. Also, there were no legal risks as long as they stayed within territorial waters. The fleets of Canadian booze ships were so plentiful that they soon became known as the "whiskito" fleet. By late 1920, the Canadian government suddenly realized how much alcohol revenue was being earned by these various export houses, courtesy of the American bootleggers, and decided to raise the annual licensing fees for these liquor exporting businesses from $3,000 to $10,000. In response, the top Canadian export houses held a series of meetings about this matter and ultimately decided to pool their resources together and form one giant export business, Consolidated Exporters Limited. This mammoth company would quickly become the single largest supplier of Canadian booze for the entire Pacific Northwest region. It opened offices in Seattle, Portland and San Francisco, establishing a formal network of contact men (otherwise known as land agents) up and down the West Coast. Obviously, in light of the Volstead Act, it was crucial to remain as discreet as possible, so Consolidated Exporters went to great lengths to legally disguise itself as well as its American customers. At its first meeting, the acting directors all agreed to burn the company books at the end of each year to protect the nature of its business. A special filing system was used where the names and addresses of its top customers were either coded or kept intentionally vague, and the land agents were instructed to never hold a meeting in the same place twice.

Olmstead's dominance in the booze market was quickly making things difficult for other rumrunners as many of Seattle's top customers were now purchasing directly from him. This introduced an unfortunate level of viciousness not previously seen before. Among the most infamous examples of this were the Eggers Brothers—Milo, Happy and Ted. Like many rumrunners at the time, the Eggers were a small-time smuggling operation who were now taking it on the chin courtesy of Olmstead's alcohol monopoly. Reasoning that stolen liquor was cheaper than purchased liquor, the Eggerses built a powerful speedboat powered by a two-hundred-horsepower engine, painted it black and named it *M-197*. They then armed themselves with revolvers and began hijacking large shipments of booze from other smuggling ships. In essence, they were modern pirates. Their first victim was a Canadian rumrunner who was anchored out in the waters of Haro Strait with 128 cases of liquor waiting to be handed off to a Seattle buyer.

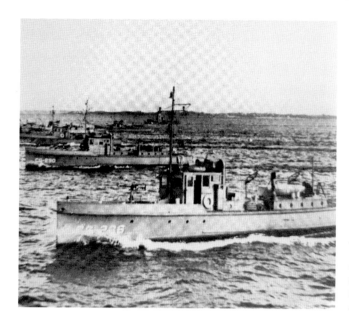

A small fleet of Coast Guard cutters out on patrol for smugglers. *Courtesy of Coast Guard Museum Northwest.*

When he saw a speedboat approaching, he assumed it was the American rumrunners whom he had been waiting for. His relief quickly turned to panic, however, when he realized the men on the speedboat were all wearing masks and brandishing guns. Before he knew it, the masked men were on his ship and he was being relieved of his precious cargo at gunpoint. After the Eggerses had loaded up the *M-197* with the hijacked booze, they then sped away and into local infamy. From there, the brothers integrated themselves amongst popular seaport locations and presented themselves as rumrunners-for-hire, hoping to gather intelligence about upcoming shipments of booze. Once a large shipment was confirmed, they would then head out on the *M-197*, slip on their masks and greet the ships at gunpoint.

Out near D'Arcy Island, the Eggers brothers seized control of *The Erskine*, which was carrying a huge shipment of booze intended for the king of the bootleggers himself, Roy Olmstead. The Eggerses filled their cargo hold full of the Olmstead's liquor and immediately proceeded down to Seattle, hoping to make a quick sale. However, word of their heist had already spread throughout the city, making the sale of their contraband a bit difficult. To make things worse, an underworld figure they owed money to had learned of the heist and attempted to blackmail them. He demanded that they hand the stolen booze over to him or he would tell Olmstead's men where they were hiding. The Eggerses declined his offer and, true to the man's word, Olmstead was informed of their whereabouts. The three brothers somehow

managed a swift escape and quickly departed over to the Haro Strait. With Olmstead's men now looking for them, they would be wise to limit their heists to Canadian waters, which is where they would remain for the duration of their days as the area's most active pirates.

By now, Johnny Schnarr was a full-time rumrunner. In one of his early fortuitous visits to Seattle, he decided to stop by a fortune-teller's shop and was told that he would have a very successful and adventurous career. It was a prophecy that would prove to be quite accurate. In his first few months out on the water, he made more than one thousand dollars in the span of just five or six trips. This was the most money he had ever made in his entire life and there was plenty more where that came from. He relied on an eighteen-foot boat with a top speed of five knots. The Coast Guard's top ship at the time had a top speed of twelve knots and boasted a cannon with a range of four thousand yards. It didn't take Schnarr very long to do the math and realize he would need something bigger and faster. His first order of business, therefore, was to build a new boat. Using all the smuggling profits that he had managed to save up, Schnarr took some time off from rum-running so he could focus on getting this new boat built. After drafting a version of it on paper he built a three-foot prototype model, which he immediately began showing to various prospective boatbuilders. He eventually settled on a father-son team of Japanese shipwrights in Victoria to complete his project. The result was a sleek, beautiful and innovative boat that he named *Moonbeam*. To power the boat, Schnarr installed an eighty-horsepower Marmon automobile engine, which allowed speeds up to eighteen knots. This would make it plenty fast enough to outrun the Coast Guard. In addition to the powerful engine, *Moonbeam* had a low-profile design and high-speed hull, making her quick and nimble for action. The design was revolutionary and proved to be quite influential for other rumrunners. *Moonbeam* would not be Schnarr's last boat but it would certainly serve as a brilliant example of all the innovative boats to come.

Overall, Schnarr's basic strategy was to remain a step ahead of the Coast Guard, as well as other rumrunners, by always making sure that he always had the fastest, smartest, most state-of-the-art ship on the water. Schnarr was also very strategic about when he made deliveries. He preferred to smuggle in the fall and winter months, when the nights were dark and the weather was stormy. To his way of thinking, traveling in such conditions minimized the risks of being caught by the Coast Guard or hijacked by pirates. Typically, he would load up at one of the Consolidated Exporters wharfs in Vancouver, British Columbia, then begin the perilous, late-night journey down the Strait

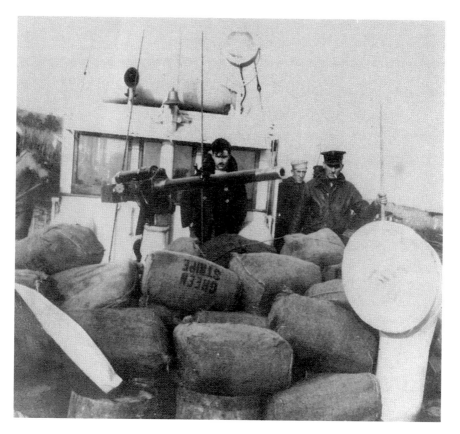

A Puget Sound Coast Guard cutter with its machine gun, as well as several sacks of confiscated liquor. *Courtesy of Coast Guard Museum Northwest.*

of Georgia and on to various delivery ports throughout Puget Sound. To confuse the authorities and avoid setting a predictable pattern, Schnarr made sure to alternate between different drop-off locations. This could include anywhere from Port Angeles to Seattle, and all stops in between.

Limiting his runs to dark, stormy nights may have reduced his risk of being caught, but it raised a new set of challenges. Chief among them was the danger of hitting a submerged log. Puget Sound was full of floating driftwood due to the area's logging industry and storm activity, and hitting one while traveling at fifteen knots could easily destroy a boat. Other dangers included powerful riptides, rogue waves and the frequent blankets of thick fog. *Moonbeam* once sustained significant damage when Schnarr accidently hit a floating log out in the foggy waters off of Dungeness Spit. Another time, Schnarr was about to make a delivery on Whidbey Island when the

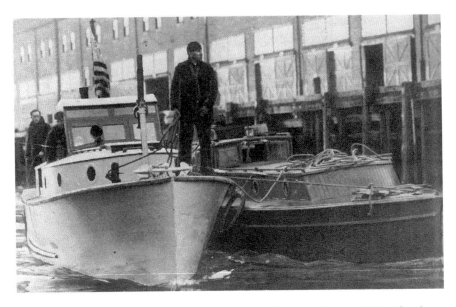

A Coast Guardsman standing next to a captured smuggling boat. *Courtesy of Coast Guard Museum Northwest.*

lights of a harbor patrol boat suddenly shone down upon him. Schnarr immediately revved the engine for a quick getaway, causing the police to open fire. Amid the hail of bullets, Schnarr managed a fast escape. The next day, however, Schnarr was moored to a Victoria wharf when a Canadian customs inspector making his daily rounds discovered one of the police bullets lodged in *Moonbeam*'s hull. It was obvious what had happened, and Schnarr was forced to pay a fine, though it made him realize that he would need an even faster boat.

By 1923, the U.S. government started to put pressure on Canada to do something about all the export houses that were supplying American bootleggers. The feds were particularly concerned about Consolidated Exporters. The Canadian government finally caved and passed a law under which foreign customers could no longer buy booze directly from the export houses. In response, Consolidated Exporters purchased three gigantic fishing boats to surreptitiously carry huge loads of booze out to the Haro Strait, just outside U.S. territorial waters, where American rumrunners could secretly rendezvous with them. Essentially, these Canadian "motherships," as they became known, acted as floating warehouses of booze anchored out on the open waters. Most of the American smugglers actually preferred this as it eliminated any official record of them buying anything illegal. Under the

new system, Seattle bootleggers would place their orders ahead of time with "land agents" working at the Seattle Consolidated Exporters office. Once the dry agent received full payment for the order, he would then give the bootlegger one half of a dollar bill with the order number written on it. When the smuggling boat later arrived at the mothership to load up an order, the crew would be required to hand over its dollar bill half to the mothership's captain, who would have received the other half in advance. The torn edges needed to perfectly fit together or no booze would be handed over. Once everything was verified, the smuggling boats were loaded up with their orders of booze and would then begin their long journey back to Seattle.

Olmstead had a steady crew of rumrunners working for him, but his most reliable smuggler was an experienced sailor named Prosper Graignic. Like Johnny Schnarr, Prosper had an instinctual knack for handling the treacherous waters of Puget Sound, and he wasn't afraid of a little bad weather. At the time, Graignic held the speed record on Seattle's Lake Washington. His forty-five-foot speedboat was powered by twin three-hundred-horsepower engines, and he was usually the one who would pick up Olmstead's shipments on D'Arcy Island as he had the nerves of steel necessary to navigate the hidden reefs and dangerous currents surrounding the island.

One late summer day, while hanging out on Discovery Island waiting for a load of booze to be dropped off, Johnny Schnarr noticed a suspicious black boat pull up. Three men were on board and they exchanged pleasant greetings with Schnarr, though he sensed something was off. For one, they seemed particularly interested in the estimated delivery times of the Canadian booze ships as well as the size of the shipments. Despite all their questions, though, they didn't seem particularly interested in actually purchasing anything. Sensing potential danger, Schnarr excused himself and secretly went to fetch his pistol from the *Moonbeam*. He was a country boy and was raised to always carry a firearm, either for hunting or sometimes for protection. This felt like a time he might need it for protection. Upon his return, he heard gunfire and braced himself for the worst. As it turned out, the three men were simply throwing empty bottles out into the water and shooting them as they bobbed up and down. Schnarr noticed a few stray bottles that they had missed so, drawing his pistol, he shattered all three bottles with an equal number of precise, well-aimed shots. The sharpshooting spectacle was intended to send a clear message that he was armed and knew how to shoot. Later that day, and after his boat was loaded up with booze, he set out for the voyage back

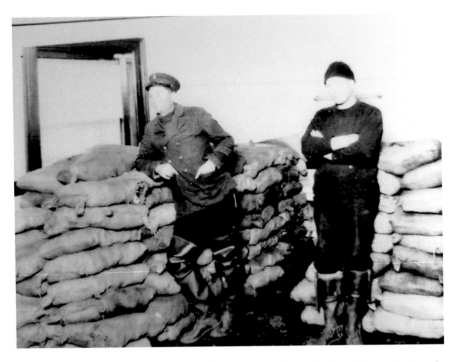

A pair of Coast Guard crew members posing next to confiscated sacks of booze. *Courtesy of Coast Guard Museum Northwest.*

to Puget Sound. Staying alert, he noticed their black boat start to follow him but, at some point, their ship turned and vanished off into the horizon. He would eventually learn that the three men were the Eggers brothers and, as he would later recall, "I always liked to think that the little demonstration of my shooting skills probably helped them change their minds."

That same year, in an effort to combat the growing surge of smuggling activity, the U.S. Customs Service launched ten new cutters to patrol the waters of Puget Sound. They boasted top speeds of eighteen knots. Likewise, the U.S. Coast Guard had finally appropriated federal funding for some new, updated ships to add to its fleet of rum chasers. Built for speed, the fifteen new "bitters" each featured twin two-hundred-horsepower Sterling engines to keep up with the fast rum-running boats. In addition, these new rum chasers were strapped with .50-caliber machine guns and rapid-firing cannons. Always staying a step ahead of things, Schnarr's response was to install a new motor in the *Moonbeam*. He had always been mechanically inclined but was now reaching the point where he could install his own engines. This time he chose a three-hundred-horsepower Fiat airplane

engine with a top speed of thirty knots—almost twice as fast as *Moonbeam*'s previous engine! However, the engine had no gears, so the only two options were going forward or reverse. Despite these limitations, the new engine made his boat one of the fastest out on the water.

Not to be outdone, Roy Olmstead commissioned a new custom speedboat to help out in his smuggling operation. He named her *Elsie*, after the woman he was seeing and would soon marry. *Elsie* set him back $50,000, but was a beautiful ship capable of carrying up to one thousand cases of booze at a time. Powered by three three-hundred-horsepower Liberty aircraft engines, the boat was capable of speeds up to thirty knots. It was said that half the city came to admire the new 102-foot boat when she was christened down on Elliot Bay. Unfortunately, *Elsie*'s engines were a little too powerful for the design of the ship and she immediately began experiencing serious problems. A month after taking the boat on her first voyage, the crew of the *Elsie*, being led by Prosper Graignic, found themselves being chased by a trio of new Coast Guard ships. *Elsie* was easily able to outrun the three rum chasers but burnt out one of her engines in the process. In October 1924, *Elsie* took her last voyage when the boat hit a freak squall on its way to the Haro Strait. The storm shook the ship so badly that the engines actually caught on fire. In the end, the crew had no choice but to launch a small lifeboat and abandon ship, watching helplessly as the *Elsie* sank to the bottom of the sound.

Soon after Olmstead's boat took her last voyage, the Eggers brothers were also taking theirs. By November 1924, the Eggers were actively being hunted down by the Canadian authorities for acts of piracy. Plenty of angry rumrunners and bootleggers were also hoping to settle some scores with the three brothers. In response, the Eggers decided to skip town and head down to San Francisco. Within weeks of their arrival, Milo and Happy were arrested by local deputies on behalf of the Canadian government and were both jailed pending extradition. In an audacious and daring move, Ted Eggers attempted to free his two brothers while they were being escorted to court. Hiding in the staircase of a San Francisco federal building, Ted waited for Milo and Happy to walk past with their armed police escorts. Leaping out as they passed by, Ted attempted to blind one of the guards with a vial full of ammonia. In the melee that followed, the two sides exchanged gunfire, leaving Happy Eggers dead with a gunshot wound to the chest. Somehow, Milo and Ted managed to escape but were now the targets of a large-scale manhunt. Six months later, Ted was arrested in Seattle and was immediately imprisoned for his crimes. Several months after Ted's arrest,

Milo was finally rearrested after a failed robbery attempt of Seattle's famed Baghdad Theatre. The Eggerses' reign of terror was finally over.

Despite the much-celebrated capture of the Eggers brothers, the threat of piracy was still being taken quite seriously. On a foggy fall morning in 1924, a lighthouse keeper in the San Juan Islands discovered an abandoned ship that had washed ashore. The name on the outside of the boat identified it as the *Beryl G*. Climbing on board and stooping down below into the galley, the lighthouse keeper found a mess of overturned furniture, random bullet holes and large amounts of blood. It was obvious there had been some kind of foul play. The Coast Guard was immediately summoned, and it was soon determined that the boat was of Canadian registry. Surmising that the *Beryl G* must have somehow drifted over to American waters, the Canadian authorities were called and the boat was towed back to Victoria.

Inspector Forbes Cruickshank, a tough, no-nonsense veteran detective with the British Columbia police, was assigned the case. It didn't take Cruickshank very long to determine that the *Beryl G* had belonged to a father-and-son team who were known to dabble in rum-running. Going through the cabin, he also found a document which referenced an American registration number. Further investigation tracked the number to a boat owned by "Legitimate Pete" Marinoff. In short order, an interview was set up between the Tacoma bootlegger and the gruff Canadian detective. Marinoff was cordial but cautious due to the nature of his business. Cruickshank assured him that he was there to solve a possible murder and was not interested in Marinoff's illegal booze operation. The bootlegger, in turn, realized that his cooperation with the detective could send a strong message to other hijackers and so the two men had a nice, long talk. During their conversation, the inspector learned that Marinoff had arranged to have one of his boats pick up two separate loads of booze from the *Beryl G*. After picking up the first load of 110 cases, Marinoff's men returned the next day for the second load but the *Beryl G* was nowhere to be found. With the Eggers brothers still fresh in everyone's memory, this was now looking like a hijacking-gone-wrong. Marinoff had no other information to provide the detective, though he mentioned the name of a local boating mechanic who "knew everyone." It proved to be a good tip, as it turned out the mechanic had heard some scuttlebutt about a small group of men who had stolen some liquor from an old man and his boy. From this, Cruickshank was able to piece together enough evidence to gather some solid leads. Within a short period of time, the grizzled detective cracked the case and arrested three men associated with the brutal crime. During subsequent interrogation, it was revealed that

they had indeed hijacked the *Beryl G* and had then brutally murdered the father and son owners of the boat in a sloppy attempt to cover up their tracks. One of the hijackers was sentenced to life imprisonment while the other two were sentenced to hang. Cruickshank made it a priority to attend the hanging. As the two men walked past him on their way to the gallows, he smiled, tipped his hat and bid them a friendly "goodbye boys."

Legitimate Pete celebrated the hangings as a strong deterrent for any other would-be hijackers and continued his bootlegging operation, which was now as strong as ever. On occasion, he would even pilot his own boats to pick up shipments of booze. On one such afternoon, with a cargo hull full of Canadian booze, he found himself being chased by one of the new Coast Guard ships. The Coast Guard ordered him to stop, which Marinoff responded to by gunning his powerful engines to maximum power. His boat was fast, but the Coast Guard had firepower and unleashed a battery of machine gun fire at his boat. The intense chase lasted for almost fifteen miles, giving Marinoff enough time to dump the booze overboard. No longer having a reason to flee the Coast Guard, he slowed down his engines and

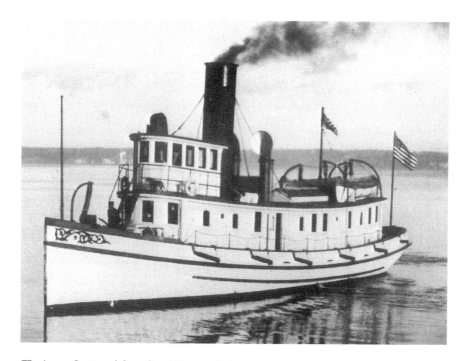

The Arcata. Courtesy of Coast Guard Museum Northwest.

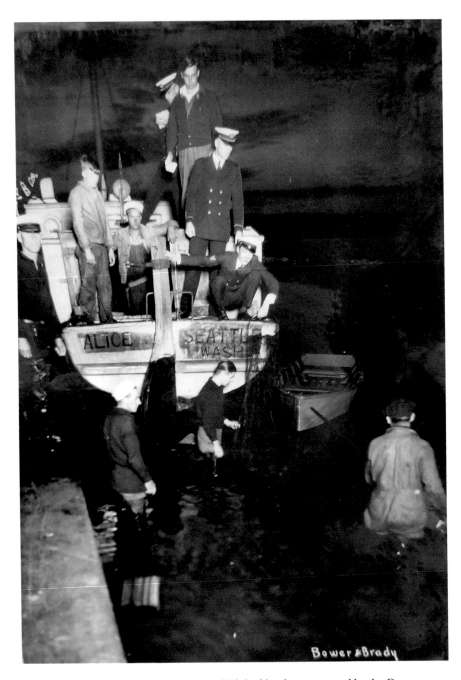

Pete Marinoff standing on his boat, *Alice*, which had just been captured by the Coast Guard in 1925. This is the only known photograph of Marinoff. *Courtesy of Coast Guard Museum Northwest.*

allowed them to catch up. As they pulled up to his boat, he casually asked, "What's all the shooting about boys?" The captain of the Coast Guard ship was less than amused, and Pete was arrested on several trumped-up charges, including no running lights.

The "Dry Navy," as it was called, was becoming more and more aggressive in its pursuit of the area's rumrunners. By early 1925, the Coast Guard had established several bases throughout Puget Sound, effectively blockading the main channel used by rumrunners. As a result, many smugglers began using Deception Pass, a narrower and more hazardous strait. Commanding this fleet of Coast Guard ships was Captain Lorenz Lonsdale. Standing only five feet tall and possessing a fiery and tenacious disposition, Lonsdale was a strict teetotaler with no patience at all for anyone caught smuggling booze. He was captain of the famous Coast Guard ship, *The Arcata*. He may have been small in stature but was very large in reputation. More commonly known as "Granddad" by rumrunners and fellow guardsmen alike, Lonsdale was never hesitant when it came to firing his cannons at offending ships. Granddad would often catch boats after they had already dumped their cargo and, knowing there was nothing he could do about it, would line the rumrunners up and then strut up and down the line of men, like an enraged rooster, giving them a loud and stern lecture on the errors of their ways. One time, Granddad spotted Pete Marinoff out on his boat, *Alice*. Aware of Marinoff's reputation, Granddad chased him down and boarded his ship to look for illegal contraband. Unable to find anything and feeling frustrated, Granddad informed Marinoff that he was towing *Alice* in for equipment violations, such as no working fire extinguishers. When they finally reached port, it was discovered that Marinoff attached several sacks of booze to lines of rope underneath *Alice* and had been secretly towing them in the water. Once again, the Tacoma bootlegger found himself in handcuffs.

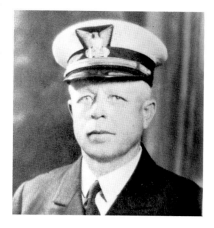

Captain Lorenz A. Lonsdale of the U.S. Coast Guard. He was nicknamed "Granddad" due to his strict, no-nonsense demeanor. His ship, *The Arcata*, successfully captured many rumrunners. *Courtesy of Coast Guard Museum Northwest.*

Olmstead's operation was also in the crosshairs of the Coast Guard. A local reporter asked one of the Coast Guard captains what he thought about a new

boat that Olmstead had purchased. He sternly replied, "Olmstead can use that craft for a fish boat, a pleasure boat, a tugboat or a ferryboat, but he will not use it to run liquor into this country. My orders will be 'Give the Olmstead boat one order to stop. If it isn't obeyed, fill her full of lead.' If the craft gets by the line of my boats, she'll be so full of holes she'll sink like a window screen." On land and sea, the war between bootleggers and the authorities was now in full swing.

THE ENFORCERS

No bootlegger gets rough treatment unless he deserves it.
—*Assistant Director of the Seattle Prohibition Bureau William Whitney*

I t was a muggy summer day when three of Olmstead's men pulled up in an alley behind a downtown hotel. They were making a large delivery of whiskey and were so busy unloading the contents from their car that they didn't notice the approach of James "Two-Guns" Johnson, a federal prohibition agent. The agent's nickname resulted from his overzealous use of guns, even in situations where such force wasn't warranted. It was a tactic that followed suit with Whitney's entire team of agents, who were known for their brutality and violence. True to his reputation, Johnson pulled out his revolver and demanded to see what was hidden in the bags. When a bottle of whiskey was revealed, Two-Guns fired his pistol in the air to summon help. This only attracted the attention of nearby pedestrians, providing a brief enough distraction to allow Olmstead's men the opportunity to make a run for it and manage an escape. The next day, the three men were shooting billiards at a downtown cigar store when Two-Guns came bursting through the back door. Once again, they made a mad dash for it, running into the crowded street outside. Johnson pulled out his revolver while in pursuit of the men, shouting, "Run from me, will you, you bastards!" The loud blast of his gun sent nearby pedestrians scattering and ducking for cover. Johnny Earl, one of Olmstead's men, collapsed to the sidewalk clutching his leg. Johnson had shot him in the thigh. Immediately, a crowd formed and started growing

hostile toward the agent. The aggressive tactics being used by the Prohibition Bureau had made them increasingly unpopular throughout Seattle, and the local citizens were starting to revolt. People started yelling threats and becoming aggressive, causing Johnson to wave his gun at the angry crowd in a clumsy attempt to keep them at bay. Farther up the street, two passing police officers saw the commotion and came running down to investigate the cause. This didn't help the situation, as the relationship between Mayor Brown's police force and Whitney's team of agents had grown increasingly acrimonious. As the two patrolmen approached, Johnson leveled his pistol at them and snarled, "I'm a federal Prohibition agent. Get out or I will shoot you too!" Neither cop backed down from Johnson's threats, causing a brief stand down. Finally, one of the officers lunged at Johnson and wrestled him to the ground, while the other grabbed his gun away and gave him a swift kick to the ribs. The crowd of onlookers approvingly broke out into applause.

When Washington State prohibition went into effect in 1916, enforcement in the Seattle region primarily fell upon a small team of twelve plainclothes police officers known as the Dry Squad. They formed a morally dubious team of men known to accept bribes and payoff money, but would take action when necessary. Typically, they acted upon the direct orders of the mayor, so whoever was running city hall generally influenced the temperament of the team itself. Under Gill, the Dry Squad was tasked with aggressively shutting down such locations as the Billingsleys' pharmacy as a way to improve the mayor's public image. Under Mayor Brown, however, the Dry Squad was instructed to focus its efforts on keeping dangerous moonshine off the streets rather than targeting local bootleggers, some of whom Brown was personal friends with. As the mayor explained to his police command, "I insist on stringent but sane enforcement of the Prohibition laws. I do not want police battering down the doors of homes in search of a quart of whiskey or raiding basements to find a pint of home brew."

Like many in Seattle, Brown had also grown weary of the pugnacious tactics being used by William Whitney and his team of dry agents. In his words, the prohibition agents were "crooks and incompetents," and he was steadfast in his refusal to ever lend them the assistance of his police force. This was first evident when Whitney and his agents arrested a team of bootleggers and Brown refused their request to house the prisoners in the Seattle city jail. Whitney complained about the incident to the press, inferring that the mayor was guilty of corruption, to which Brown responded, "I can only reply by quoting the old saying about people who live in glass houses." The feud between the two men had officially begun, and Brown upped the ante a few

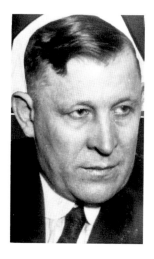

Assistant director of the Seattle Prohibition Bureau William Whitney. Whitney's team consisted of federal agents known for their brutality. *Author's collection.*

months later when his Dry Squad caught three federal agents selling confiscated liquor from the trunk of their car and arrested them on the spot. The three agents were charged, further tarnishing their image amongst local Seattleites.

William Whitney had established a name for himself several years prior when, as a young attorney, he joined a well-known law firm dedicated to the promotion of Republican politics. Along with Lyle, he was a member of the Seattle Young Men's Republican Club, even serving as its president for a few years. When it came time for the newly formed Prohibition Bureau to select its directors, Whitney's prominence in local political circles caught the eye of Washington State's ranking Republican senator, Wesley L. Jones, who was also a longtime member of the Anti-Saloon League. Unfortunately, Whitney was politically tainted, as he had recently been involved in a messy public scandal involving a married woman, so Roy Lyle was offered the director's position instead. When Lyle later selected Whitney to be assistant director and tasked him with supervising the twelve Prohibition agents (the same number of men as on the Dry Squad), it soon became apparent that Whitney was actually the one who was unofficially running things. Whitney viewed himself a righteous Christian warrior waging a war against the immorality of the illegal booze market.

Energetic in his pursuits against local bootleggers, Whitney and his agents quickly gained notoriety for their ruthless and heavy-handed tactics. They were viewed as rough and brutal enforcers, known for carelessly firing their guns in public, beating people up and trashing many of the places they raided. At the time, federal agents were paid little but were expected to work long hours. In order to supplement their incomes, they were known to accept bribes as well as resell whatever booze they had confiscated. Most of the agents were also known to be heavy drinkers, giving them another incentive to seize liquor off the streets. Their unpopularity with local residents was so pronounced that the *Seattle Star* published an editorial urging that Whitney be fired. Some of the agents were more well-known than others. Along with "Two-Guns" Johnson, William Thompson established himself as a

particularly brutal and hard-drinking agent who was known for beating prisoners with a police baton known as a blackjack. Nicknamed "Kinky" for his tight curls of dark hair, Thompson had a career with the bureau that was marked by several violent incidents, including one in Port Townsend when he angered a crowd of locals after pistol-whipping a handcuffed suspect on one of the town's main streets. Another time, he unnecessarily shot a suspected moonshiner in the stomach. Whitney welcomed such behavior, advising his agents to "beat the hell out of bootleggers and drag them out by the feet." Following the arrests of his agents by the Dry Squad, Whitney now added Mayor Brown's name to the list of men he wished to bring down. The only two men he wanted more were Roy Olmstead and Frank Gatt, and his pursuit of these men would often border on obsessive.

By spring of 1923, Whitney had become aware that Frank Gatt was the area's top supplier of moonshine and started an investigation into Gatt's various business affairs. He ordered his men to tail Gatt, though this usually proved to be futile as they could never keep up with Gatt's souped-up sedan. In November of that year, Whitney received a tip that one of Gatt's restaurants, the Lakeview Inn, was openly serving alcohol to its guests. Bringing a few of his agents along with him, Whitney decided to personally pay a visit. In typical fashion, they broke down the back door of the restaurant with sledgehammers, ordered everyone to the floor and immediately began a destructive search of the entire premises. Upstairs, they discovered a secret compartment with a couple of hundred bottles of Canadian beer and several bottles of Gatt's hooch. Frank Gatt and his men were subsequently arrested and charged with violation of the Volstead Act. Unfortunately for Whitney, Gatt had already prepared for such an event, and when the case went to trial, his attorneys produced a stack of legal paperwork comprised of an elaborate and complicated series of property deeds that exonerated him as being the owner of the restaurant. It was nothing more than a legal sleight of hand on Gatt's part, since everyone knew he was the true owner of the place. His tactic worked, though, and since the feds were unable to prove that Gatt was indeed the proprietor of the Lakeview Inn, he and his men were acquitted of all charges. For Gatt, the resulting publicity only earned him even more business.

While Whitney was busy investigating Gatt's moonshine operation, Edwin "Doc" Brown was actively campaigning for his 1924 reelection bid. The usual forces of temperance publicly came out against him, including the Reverend Mark Matthews, who declared that the mayor had turned the city into "an orgy of crime." On the opposite side of the spectrum, the local

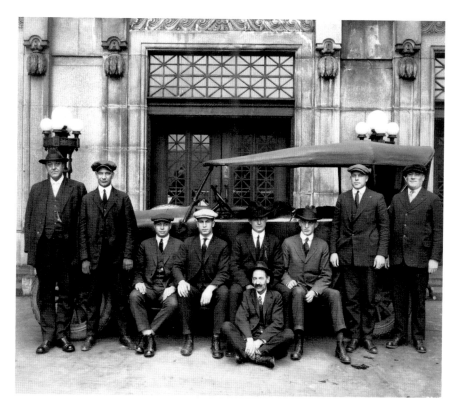

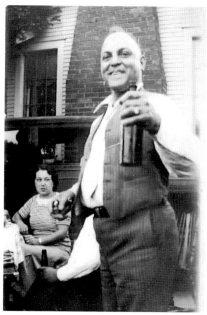

Above: The Seattle Dry Squad was a team of plainclothes police officers tasked with enforcing Prohibition within the city. *Courtesy of Seattle Municipal Archives.*

Right: Frank Gatt enjoying a merry backyard moment with his family, 1920s. *Courtesy of Jewelli Delay.*

vice syndicate contributed generously to Brown's reelection efforts, including Roy Olmstead himself, who made several large payments to the Brown campaign. This resulted in an exciting mayor's race with capacity crowds of supporters on both sides. On the campaign trail, Brown was his usual eloquent and charismatic self, emerging on the stage to the accompaniment of lively jazz music and energizing the crowds with his passionate speeches. He assured his audiences of wets that "as long as people will buy liquor, they will find bootleggers who will sell it to them." With public support of Prohibition laws dwindling by the day, Brown easily won the race and was reelected for a second term as Seattle mayor.

Soon following Brown's victory, however, the bootleggers who paid large sums of money to help him get reelected started arriving to collect their favors. Olmstead, in particular, benefited greatly from Brown's reelection as he had two brothers still on the police force. One of the brothers, Ralph, was promoted to inspector and was placed in charge of the highly coveted downtown day shift. His other brother, Frank, was promoted to sergeant and was assigned to Chinatown, which was generally regarded as one of the best beats for collecting payoff money. In addition, three of Olmstead's close police friends were put in charge of the Dry Squad. Olmstead's total and complete control of the local booze racket was now complete.

Al Hubbard—the boy genius who had earlier been invited to live at Olmstead's sprawling manor—was now working for Olmstead's bootlegging operation in an official capacity. Initially, he used his mechanical skills to help keep Olmstead's boats running at peak performance with frequent upgrades to faster engines. He also began installing radio transmitters on the boats, allowing the crews to communicate with spotters along the Strait of Juan de Fuca. There were even stories that Hubbard had equipped local taxis with radar systems used for monitoring local Coast Guard activity. As time wore on, though, he eventually became more integrated in the business itself. Olmstead served as his mentor, teaching the young Hubbard all the ins and outs of the bootlegging racket including the art of bribery and how to place orders with Consolidated Exporters. Not surprisingly, Hubbard was a fast learner and, in no time at all, was one of Olmstead's most trusted lieutenants.

Despite his immersion in Olmstead's business, Hubbard still enjoyed tinkering away in his basement laboratory and he began working on building a radio tower. By this time, Olmstead was able to read the tea leaves and see that the aggressiveness of the Prohibition Bureau meant

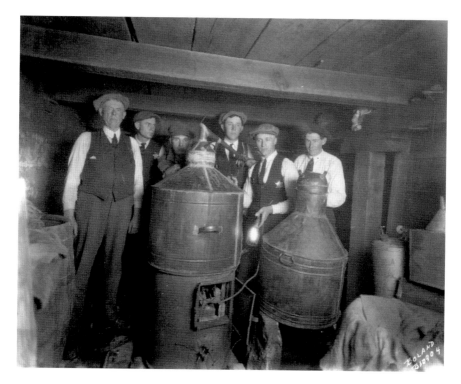

Tacoma law enforcement posing next to a moonshine still following a raid in 1924. *Courtesy of Washington State Historical Society.*

he should probably be searching for other ways to earn money. So he decided to create Seattle's very first radio station. With the assistance of Hubbard's technical prowess, KFQX hit the Seattle airwaves in the autumn of 1924. Powered by a one-thousand-watt radio tower, the radio station was run from Olmstead's Mount Baker home. The station would air nightly broadcasts which mostly consisted of news and weather. Afterwards, Olmstead's wife, Elsie, would air her popular program *Aunt Vivian*, in which her character would read bedtime stories to a dedicated fan base of local children. This led to the popular idea that Elsie was secretly inserting coded messages into these stories in order to assist her husband's bootlegging operation. This has neither been proven nor debunked and, whether true or not, remains a popular urban legend. At some point, Olmstead added another radio tower on the top floor of the Smith Tower, which, at the time, was Seattle's tallest building. Live jazz was soon added to KFQX's programming lineup and, before long, sponsors were lining up to purchase advertising spots.

Roy Olmstead operating radio station KFQX out of his home in 1924. This was Seattle's first radio station and would eventually become KOMO. *Courtesy of Museum of History and Industry (MOHAI).*

While Seattle fell in love with its new radio station, one listener in particular was less than amused. From Whitney's perspective, that Seattle's top bootlegger would have the gall to start a radio station was a kick in the face to the very idea of law and order. He began an immediate stakeout of Olmstead's residence and ordered his men to focus their efforts on the bootlegger's business operations. This mostly proved to be a dead end, though, as Olmstead had paid off half the city. Whitney decided to take things even further when he hired local technicians to tap Olmstead's phones, at both his residence and his various offices. At first, the wiretaps gave Whitney some much-needed insight into how Olmstead was running his business. In fact, one of the first calls he intercepted was that of Olmstead's men discussing a large delivery of booze to a local hotel. Whitney sent one of his top agents to pay a visit to this upcoming delivery, which is when "Two-Guns" Johnson had his fortuitous encounter with the three delivery men.

Whitney enlisted the help of local stenographers who would listen in on Olmstead's phone calls and transcribe the conversations for Whitney's

personal review later on. Slowly, Whitney was able to uncover many of Olmstead's secrets regarding how he ran his operation. Things hit a road bump when one of Whitney's disgruntled wiretappers tipped Olmstead off that his calls were being eavesdropped on. After this, Olmstead was careful about what he said and ordered his men to begin taking orders using payphones. While remaining cautious, Olmstead also saw this as an opportunity to toy with Whitney and began using the wiretapped phones to give intentionally misleading information, such as false landing sites for his boats. The idea of Whitney spending a cold, lonely night on a beach waiting for a shipment of booze that would never actually arrive would send Olmstead into fits of laughter. Other times, Olmstead would get on one of the wiretapped phones and discuss what an "incompetent dimwit" Whitney was, knowing that the entire conversation would be transcribed and read by the assistant director the next day.

One of these phone pranks even gave Olmstead and Whitney the opportunity to meet in person for the first time. The whole thing started when Olmstead used one of the tapped phones to set up a fake delivery of booze to a downtown garage. The next day, at the exact time of the specified delivery, Olmstead made a show of having several cars arrive at the garage. For extra authenticity, he even had his men get out of their cars and suspiciously look around before entering. Whitney, who had obviously taken the bait, was staked out across the street with a few of his agents. Olmstead made sure that he was the last one to arrive and, as soon as he entered the garage, Whitney and his men drew their guns and proceeded over. Upon entering the garage, however, Whitney and his agents were met by Olmstead and his men standing with their arms crossed. As soon as Olmstead broke into laughter, Whitney realized that he had somehow been tricked. He ordered his agents to search the premises anyway but, as he suspected, no booze was to be found. Throughout the whole affair, and between bursts of laughter, Olmstead mercilessly taunted Whitney: "We all brought our cars here to have them repaired. Certainly you are not going to take us downtown for that." As things started winding down, Olmstead even suggested that all the men go have breakfast together. Whitney was fuming. To further add salt to the wound, Olmstead leaked the whole story to the local papers so the entire city could be in on the joke.

Over in city hall, Mayor Brown was preparing to depart for New York in order to attend the upcoming Democratic National Convention. In such situations, and per protocol, the president of the Seattle City Council serves as acting mayor. In this case, that honor fell upon Bertha Landes, a short and

stout middle-aged woman known for her support of the temperance movement and her outspoken beliefs that Prohibition laws should be strictly enforced. Needless to say, she was no fan of Doc Brown or his tolerance of local bootleggers.

As soon as Brown stepped aboard the departing train, Landes ordered the chief of police to immediately fire any officers who had ever been suspected of corruption. She then appointed her own chief of police and ordered him to close every speakeasy in the city. For her, it was a race against time, for she knew Brown would be back soon and she intended to do as much damage as possible before his return. Local bootleggers, soda shop owners and speakeasy keepers all felt the heat. The upheaval even affected Olmstead's business though, in typical

Bertha Landes, 1920s. Landes had the distinction of becoming the first woman to be elected mayor in a major American city. *Courtesy of Seattle Municipal Archives.*

fashion, he shrugged most of it off, telling his lieutenants, "We will just have to take things easy and look after our best customers only until Doc gets back." When Mayor Brown finally did arrive back to Seattle, he reappointed his original police chief and things were soon restored back to normal working order.

Following Olmstead's public humiliation of Whitney, the assistant director dedicated all his time toward retribution. He increased his wiretapping of Olmstead's operation, carefully recording each conversation and having it transcribed by stenographers into official documents. His men surreptitiously conducted twenty-four-hour surveillance of Olmstead's operations until, by fall of 1924, Whitney had gathered enough evidence to obtain a search warrant. He not only wanted revenge but also wished to restore his reputation. His career was still blemished by the earlier married woman scandal, and his bumbling and unsuccessful attempts to shut down Olmstead and Gatt had put his job in jeopardy as he and Rob Lyle were now under the very overt threat of being fired due to ineffectiveness.

On the evening of November 17, 1924, several cars pulled up outside Olmstead's residence and a small army of dry agents emerged carrying an arsenal of shotguns, sledgehammers, axes and revolvers. Leading the

delegation was William Whitney, with the freshly signed search warrant planted firmly in his hand. He had even invited his wife, who walked briskly at his side, to accompany him. Knocking loudly on the front door, Whitney and his team were somewhat taken by surprise when Olmstead himself opened the door and welcomed them all inside his home. Inside were Al Hubbard and one of the operation's swampers. Olmstead and his men were ordered into the dining room and held at gunpoint while the agents began an aggressive search of the house. Upstairs, his wife, Elsie, was in the middle of doing her *Aunt Vivian* radio show. One of the agents barged in while she was live on the air and ordered her to shut down her program. She loudly protested, but the agent aimed his gun at her while hitting the off switch and ordered her downstairs to stand with her husband. To the kids listening that night, it must have been a rather memorable show. Whitney and his team then proceeded to tear Olmstead's nine-bedroom house apart looking for evidence. They managed to seize assorted business documents and tax records but were unable to find so much as a single bottle of alcohol. One of Olmstead's distributors, unaware that a raid was taking place, unexpectedly showed up at the front door with a half-emptied bottle of whiskey. He was immediately arrested and the bottle of booze confiscated as evidence. Soon after, Olmstead's home telephone rang and Whitney answered with a friendly hello. The voice on the other end, assuming it was Roy, asked if it was OK to stop by. "Of course," answered Whitney, "I'll be here." At this point, Whitney summoned his wife over and, using a list of telephone numbers he had compiled over the past few months, the two of them impersonated Roy and Elsie's voices and proceeded to make a series of calls to many of Olmstead's top associates, inviting them over to the house for a "party" and asking them to bring bottles of booze with them. Some became suspicious and wisely chose to stay away, but a few of Olmstead's associates arrived and were promptly stripped of their booze, arrested and commanded to go sit with the others in the dining room.

Early the next morning, Whitney loaded everyone up and brought them all downtown to the Prohibition office for further interrogating. Later on, when everyone was finally released, local newspaper reporters were anxiously waiting outside the doors. When asked for a comment, Olmstead replied, "I'm not worried in the least. The agents didn't find a drop of liquor in the house. Every bit of liquor they seized they got by calling up bootleggers." Mayor Brown was furious as he read about the raid in the morning paper. Talking to reporters, he did not mince his words. "There is a difference between enforcing the law and making a grandstand play. They could raid my home

in the same way; come to my home and search it; find no liquor and then telephone bootleggers who would bring it. They could raid the Reverend Matthews house the same way." Despite the mayor's terse statement, Lyle and Whitney were celebrating the raid as an important victory. They felt confident that the seized documents, along with the wiretaps, were enough evidence for a grand jury.

A few months after the Olmstead raid, Whitney and his men conducted a raid of Frank Gatt's moonshine operation at the Nelson Dairy Farm. They had been staking out the location for several months and, feeling motivated by the success of the Olmstead raid, decided to go after Gatt. Nobody was actually there on the property when they pulled up. Entering the barn, the team of agents marveled at the size of the stills. No one had ever seen a moonshining operation this large before. In fact, at the time, it was the biggest such bust in the entire country. In one of the tanks, they found over seven thousand gallons of mash waiting to be processed into hard liquor. The agents dutifully began tearing down all the equipment and issued warrants for Gatt and his top men, who were all rounded up, arrested and charged with conspiracy to manufacture illegal alcohol. Once again, Whitney was confident that he had an airtight case. However, when it later went to trial, he was unable to conclusively prove, beyond a shadow of a doubt, that Gatt was indeed the owner of the dairy farm or that he was involved in the moonshining operation which had been discovered there. After a short deliberation, the jury came back with non-guilty verdicts. Gatt and his men celebrated their second victory against Whitney and, undeterred, went right back to bootlegging.

Things didn't go so well for Roy Olmstead. On January 9, 1925, a federal grand jury returned a two-count indictment against Olmstead and ninety other defendants, including Doc Hamilton, Al Hubbard and several of Olmstead's most trusted lieutenants. Based on Whitney's wiretaps and the records he seized in the raid, the suspects were all charged with conspiracy to violate the National Prohibition Act. Known as "The Whispering Wires Case," due to the extensive wiretapping involved, the resulting legal proceeding would end up being the biggest Prohibition trial in history. It was so massive, in fact, that certain parts of the case would make it all the way to the Supreme Court, with legal ramifications that continue to this day. Leading up to the trial, some of the defendants panicked and fled to Canada, including Olmstead's top rumrunner, Prosper Graignic. Others offered to plead guilty and testify in exchange for more lenient sentences. Adding to this, Whitney began a campaign of intimidation directed toward many

Local Form No. 103 (Revised to April 1, 1927).

UNITED STATES OF AMERICA
~~Western~~ District of Washington } as SEARCH WARRANT.
~~Northern~~ Division

THE PRESIDENT OF THE UNITED STATES to the Marshal of the United States for the ~~Western~~ District of Washington, and his deputies, or either of them; and to the Federal Prohibition Administrator, or to any Federal Prohibition Officer or Agent; and to the United States Commissioner of Prohibition, his assistants, deputies, agents or inspectors, or either of them, GREETING:

WHEREAS, G.D.Murray , A FEDERAL PROHIBITION AGENT, has this day made application for a search warrant and made oath in writing, supported by affidavit of _____ taken before the undersigned, a Commissioner of the United States for the ~~Western~~ District of Washington, charging that a crime is being committed against the United States in violation of the National Prohibition Act by one _____

~~John Doe Jordan, Richard Roe James, prop. and that employes whose true names to~~

~~affiant are unknown~~

who was, on ~~or about the~~ 6th day of March , 192 8 , and is, at this time and place, possessing a still and distilling apparatus and materials designed and intended for use in manufacturing intoxicating liquor, and manufacturing, possessing, transporting, and selling intoxicating liquor, all for beverage purposes, on certain premises in the City of Seattle , County of King , State of Washington, and in said District, more fully described as

405-24th. Avenue, North, Seattle _____

and on the premises used, operated and occupied in connection therewith and under the control and jurisdiction of said above parties;

AND WHEREAS, the undersigned is satisfied of the existence of the grounds of the said application, and that there is probable cause for the issuance of a search warrant,

NOW, THEREFORE, YOU ARE HEREBY COMMANDED, and authorized and empowered in the name of the PRESIDENT OF THE UNITED STATES to enter said premises with such proper assistance as may be necessary in the day time, or night time, and then and there diligently investigate and search the same and inquire into and concerning said crime, and to search the person of said above named parties, and from him or her, or from said premises seize any and all of the said property, documents, papers and materials so used in or about the commission of said crime, and any and all intoxicating liquor and the containers thereof, and then and there take the same into your possession, and true report make of your said acts as provided by law.

GIVEN under my hand and seal this 6th day of March , 192 8 .

A.C.Bauman
United States Commissioner
Western District of Washington.

A federal search warrant carried out by Prohibition agents in 1928 for a suspected moonshine still. The address listed was in Seattle's Capitol Hill neighborhood. *Author's collection.*

of Olmstead's top customers in which he contacted each one individually and falsely told them that he had incriminating evidence which would be used to prosecute them unless they agreed to testify against Olmstead. His tactic worked, with over thirty of Olmstead's customers agreeing to testify. To further solidify his case, Whitney also doctored some of the typed conversations he had compiled from his wiretaps. He desperately needed to win this case and was using any strategy at his disposal, no matter how unscrupulous the methodology.

Out in the waters of Puget Sound, the local Coast Guard had increased its numbers and introduced a small fleet of "six-bitters," which were steel-hulled boats powered by twin diesel engines and capable of up to twenty-five knots. In addition to the usual cannons, the six-bitters boasted Lewis machine guns and could stay out at sea for up to a month at a time. Just as the feds were going hard against bootleggers on land, the Coast Guard was taking the proverbial gloves off and playing tough on the water. Guardsmen would shadow the Canadian motherships and form a nearby flotilla, waiting to ensnare American rumrunners. Once they had a smuggling boat in their crosshairs, they would then aggressively chase it down until it was either caught or sunk. Captain Dodge of the Puget Sound Coast Guard arrogantly boasted to the local press, "We have them on the run. By next summer there won't be a drop of liquor brought direct from British Columbia by water routes." Local papers picked up on the increased combativeness of the Coast Guard with such sensational headlines as "Shoot to Kill Orders Given by Puget Sound Rum Chasers" and "If Rumrunners Fail to Stop, Sink Them!"

The newly strengthened Coast Guard even managed to take out Johnny Schnarr's boat, *Moonbeam*, though he wasn't on board when it happened. He had let two of his associates use the boat to pick up an order of booze from Consolidated Exporters. After crossing the line back into U.S. waters, they were spotted by two of the new six-bitters, which immediately began pursuit. The Coast Guard ships opened fire on *Moonbeam* while aggressively giving chase. Unfortunately for the two men, they lacked Schnarr's piloting skills and were unable to shake the six-bitters, with *Moonbeam* coming under heavy fire. They managed to steer the boat to a spit near the San Juans and run her up onto a beach. From there, the two men jumped off and made a run for it into the woods. The Coast Guard was still firing on the boat as they ran away. Schnarr was saddened to lose his beloved *Moonbeam*, but its demise simply afforded him the opportunity to build a faster and newer boat. By this time, he had a loyal base of customers due to his unparalleled reputation and, with so many of his fellow rumrunners having been caught,

his services were in demand more than ever before. One of his biggest customers was down in Tacoma: "Legitimate Pete" Marinoff, who helped finance the construction of Schnarr's new boat. The two men enjoyed a close friendship and could always count on one another to have each other's back. In this case, Pete needed a reliable rumrunner to help him stay in business and Schnarr needed a new boat. With Marinoff's financial backing, Schnarr immediately set out to work. As always, he intended to stay a step ahead of the Coast Guard and installed two three-hundred-horsepower Fiat airplane engines, allowing speeds up to thirty knots even while carrying a full load of booze. Schnarr added other new features as well, such as a metal fin he welded underneath the hull to protect the propellers against driftwood. Upon completion, he christened his new forty-eight-foot boat, *Miss Victoria.*

On the morning of January 12, 1925, a federal grand jury convened in a downtown Seattle courtroom to hear evidence for the Whispering Wires Case. True to his nature, Whitney found himself alone with the jury foreman and used the opportunity to threaten the foreman with false allegations unless he "persuaded" the jury to offer full indictments against Olmstead and his crew. It seemed to have worked, as Olmstead and ninety other conspirators were charged with "acts against the peace and dignity of the United States of America." The two official charges were cited as "illegal importation of liquor from Canada" and the "illegal distribution and sale of intoxicating liquors." Each individual charge carried a $10,000 fine and up to two years in prison. With the charges now made official by the Seattle grand jury, this was shaping up to become the biggest such trial in the history of the United States. After the grand jury verdict was read, most of the people listed on the indictment were rounded up and arrested. For those who had fled to Canada, warrants were issued for their arrests. Olmstead posted bail and returned to work, setting all his boats, cars and an army of swampers back into motion again. He even devised a new scheme to smuggle Canadian alcohol into the United States by railroad. The trial for these charges wouldn't be for another year and, in the meantime, he had a thirsty city to accommodate.

Feeling the heat, Al Hubbard, who was among those being charged, decided to meet with Whitney and become an informant in exchange for having his name dropped from the grand jury indictment. Hubbard's proficiency as a bootlegger had elevated him to become the operation's chief lieutenant, tasked with directly fulfilling orders with Consolidated Exporters and then having everything delivered throughout the Seattle region. With such a wealth of insider knowledge, Hubbard knew that he had some significant leverage when it came to negotiating an agreement with Whitney.

Roy Olmstead next to his wife, Elsie, in 1925. *Courtesy of Museum of History and Industry (MOHAI).*

In addition to having his name erased from the indictments, Hubbard insisted that he also become appointed as a Prohibition agent. This was certainly a bold proposal on Hubbard's part and completely unorthodox in terms of agreements typically offered to informants. But Whitney was desperate to see this case through to the end and, knowing that Hubbard's testimony would all but assure a guilty verdict for Olmstead, hesitatingly agreed to Hubbard's proposal. Such an unconventional arrangement took a considerable amount of political maneuvering but, with Senator Jones's assistance, the twenty-

two-year-old Hubbard received an official appointment, making him the youngest Prohibition agent in the entire country. There were stipulations, though. He would work exclusively as an undercover agent embedded in Olmstead's business, and would not have any access to any other federal operations. In exchange, Hubbard's name was quietly dropped from the Whispering Wires indictment. As would later be revealed, Hubbard had other financial motivations for wanting to become a Prohibition agent, for he realized such an arrangement would allow him to play both sides for his own financial gain. Now operating as a secret undercover agent, Hubbard continued to work as Olmstead's top lieutenant during the day, and would later meet with Whitney to feed him information at night.

Johnny Schnarr was now using *Miss Victoria* to make regular nighttime deliveries. He had specially designed it to run at top speeds even with a full load, so being caught by the Coast Guard was not much of a concern. Floating driftwood, on the other hand, remained his biggest problem, even with all the modifications he had added. Luckily, he knew the owners of a good machine shop and every three or four trips, he would take *Miss Victoria* out of the water and have any bent props, twisted shafts or bullet holes easily repaired. Olmstead's top boat at the time was the *Estrella*, and with the Coast Guard putting a chokehold on the main routes used by rumrunners, he was bringing his liquor through Deception Pass near Whidbey Island. It was a narrower and riskier strait than what they used before, but he had rearranged his operation so that liquor would be smuggled down through the new route, dropped off at the city of Everett and then trucked down to Seattle.

One dark night in late fall, the *Estrella* was racing down Deception Pass when the crewmen suddenly found themselves being fired upon by a Coast Guard cutter. Bright tracer rounds lit up the entire area. A high-speed chase ensued, with thousands of rounds raining down upon Olmstead's prized boat. The crew had no choice but to steer the *Estrella* into shallow waters in a desperate attempt to flee the Coast Guard. The plan worked at first, but the boat eventually struck a submerged log, sinking her for good. The incident served as yet another chink in Olmstead's armor, though it certainly wouldn't be the last.

On Thanksgiving Day 1925, Olmstead and his men were unloading a shipment of booze on Woodmont Beach, south of Seattle, when a trio of armed Prohibition agents stepped out of the woods and ordered all of them to put their hands up. Along with Olmstead, the agents arrested a small crew of swampers, a sheriff's deputy (who was obviously on Olmstead's payroll) and Al Hubbard. The agents were completely unaware that Hubbard was a

fellow agent or that he had been working undercover, so he was handcuffed along with the others. While searching the delivery cars, the agents gleefully discovered over one thousand sacks of whiskey and gin. Whitney was notified of the arrests and immediately drove down. He and Lyle were both jubilant about the news, with the glaring exception of Hubbard's involvement; Hubbard offered the flimsy explanation that Olmstead had sprung the delivery on him at the last minute and so he didn't have time to sneak away and alert anybody. For Whitney, it was one of the first signs that Hubbard was playing both sides. As for the deputy arrested at the raid, he turned out to be the nephew of King County sheriff Matt Starwich, and the incident further magnified the continuing feud between Seattle law enforcement and the feds. The next day, Whitney filed charges against all the men. There would now be a second trial for Olmstead.

Two months later, on January 18, 1926, the trial for the earlier Whispering Wires Case began. Roy Olmstead and ninety other defendants were facing serious charges which could earn each of them up to four years in prison. Representing Olmstead was his longtime attorney, Jerry Finch, who had been an active part of Olmstead's business empire since the very beginning. Finch's strategy was simple and straightforward: present Olmstead as a responsible and important asset to the city who not only gave Seattle its first radio station, but was also a solid man of business who helped employ countless local citizens. As far as all that "bootlegging stuff," Finch dismissed the whole thing as Olmstead having a casual interest in Consolidated Exporters, though he was unaware of the company's role in the liquor trade. Unfortunately, the prosecution had transcripts of Olmstead's incriminating telephone calls, as well as records seized from his house. Finch and the defense team worked feverishly to have the wiretaps ruled as being inadmissible, claiming that such evidence was unconstitutional. The judge presiding over the case, a well-known Dry, disagreed and ruled in the prosecution's favor that the transcripts could be used as admissible evidence. Legally, the issue of wiretaps was an unprecedented event and the trial now had national attention.

The whole thing lasted almost a full month, with both sides taking time to present solid, well-reasoned arguments. Among the various witnesses taking the stand was local airplane mogul and frequent Olmstead customer William Boeing, who, to the frustration of the prosecution, gave intentionally vague answers no matter how pointed their questions. Olmstead managed to maintain a poised and confident demeanor throughout the proceedings. He was still very well-liked throughout the

city, and during recesses he could be seen out in the hallways, laughing and talking to his numerous supporters who would dutifully show up to the courthouse each and every day as a show of solidarity. Back in the courtroom, when some of Olmstead's phony telephone calls were read to the jury, Olmstead would roar with laughter, amused at his own antics. Naturally, the trial was front-page news in all the local newspapers, with each day's events being breathlessly covered in great detail.

After the closing arguments were presented to the jury, the judge instructed the jurors to be fair and impartial during their deliberations, but made sure to add that "a conspiracy has been established between Olmstead and some of the defendants on both counts. But you are not to take this opinion into consideration." At this point, it was clear to everyone who the judge sided with. The jury began its deliberations at 9:00 a.m. and returned to the courtroom with its verdicts later that afternoon. The entire city sat on edge, waiting for the decision to be announced. The judge asked the jurors if they had reached their verdict, to which the foreman replied, "Yes we have, your honor," and walked over to hand him the sealed envelope. The judge carefully opened the envelope and read the pages inside with no change of facial expression. The courtroom was deadly silent and filled with palpable anticipation. Finally, the verdicts were read. All ninety defendants were found guilty on both charges. Olmstead was given the maximum sentence of four years in prison and fined $8,000. From the gavel, the judge used this as an opportunity to publicly admonish the famous bootlegger, lecturing, "As for you Mr. Olmstead, and I'll say this to the rest also, that if you had shown the same enterprise, the same constructive force and the same organization devoted to legitimate, constructive enterprises in harmony with the law, the results would have been simply marvelous, and you all would have reaped a rich harvest."

If there was any silver lining for Olmstead, it was that he would not have to begin serving his prison sentence until after the conclusion of his other, upcoming trial for his recent arrest at Woodmont Beach. In the meantime, Olmstead needed to cover his fines and all associated legal costs, so he immediately put his house and radio station up for sale. As for the case itself, the issue of wiretapping had ignited fierce legal debate and *Olmstead v. United States* would become a landmark case, eventually making it all the way to the Supreme Court.

Over in city hall, Doc Brown was back in campaign mode, running for a third reelection in a very tight and energetic race against Bertha Landes. The political climate of the city had been transformed by the Olmstead trial,

King County sheriff Matt Starwich posing with a group of Scottish flappers for the local press. *Courtesy of University of Washington's Special Collections.*

with the guilty verdicts now tipping the race in Bertha's favor. Once again, just like in the days of Hiram Gill, the Seattle mayor's race became a moral referendum, with the Drys on one side and the Wets on the other. In support of Landes, and with his vendetta against Brown still relatively fresh, Whitney launched a series of well-publicized speakeasy raids just before the election date. Landes, in turn, invoked Hiram Gill's corrupt legacy and used the raids as evidence that Brown had returned Seattle back to being an Open Town, adding that city hall needed a good "municipal housecleaning." On March 9, 1926, Bertha Landes won the election by more than five thousand votes, becoming the first female mayor of a major American city.

While Landes was still celebrating her victory, the *Seattle Star* published an article revealing that Al Hubbard had secretly been working as a Prohibition agent on behalf of Whitney. Hubbard's secret was now public knowledge. Olmstead surprisingly appeared to take the news in stride, and the two would still be occasionally spotted together, leading some to further question Hubbard's loyalties and if the whole thing had been set up by Olmstead

himself, who had returned to his bootlegging business while out on bail. It was an odd situation that raised many an eyebrow though, for the time being, Hubbard remained working as a federal agent.

In early 1927, Frank Gatt and his brother, John, sat inside their downtown restaurant, the Monte Carlo. As usual, the place was packed with customers, many of whom were there exclusively for the alcohol. Earlier that day, two disgruntled ex-employees of the Monte Carlo had decided to tip off the feds and give them incriminating evidence about Gatt's illegal operations at the popular establishment. Upon receiving the tip, three federal dry agents decided to conduct a raid. Barging in through the front doors, the agents pointed their guns at the Gatt brothers and ordered everyone down on the ground. Using the information provided to them, the agents had little trouble finding all the hidden caches of illegal booze. In a hotel room above the restaurant, which Gatt used for storage, agents found over a hundred gallons of assorted spirits, five kegs of beer and several cases of homemade moonshine. Gatt and his associates were immediately handcuffed and, while they stood watching, the Prohibition agents took out fireman's axes and gleefully proceeded to demolish the interior of the restaurant, including all the billiard tables and the beautiful mahogany bar.

Whitney was working hard on Olmstead's upcoming trial but celebrated Gatt's arrest as a way to also bring down the Dry Squad and hopefully bring disgrace to Edwin Brown's previous time as Seattle mayor by demonstrating how corrupt his administration had been. If he could establish conspiracy between Gatt and Olmstead's operations and the police, then he could finally bring down the entire racket.

Despite these high-profile raids and arrests, Whitney's teams of agents continued to receive bad press due to their brutal and heavy-handed tactics. William "Kinky" Thompson, in particular, was becoming known for his viciousness. Prior to starting his shifts, Kinky and his partner would generously partake in confiscated liquor and then proceed to go on drunken rampages. Newspaper accounts of Thompson's actions at the time are harrowing. In one report, Kinky drunkenly used his blackjack to brutally beat a twelve-year-old boy, as well as his mother and father. When asked for comment, Lyle dismissed the story as "bootlegger propaganda." Not long after, Kinky and his partner crashed their car into a downtown clothing store after consuming three pints of Gatt's moonshine, which they had lifted from the evidence room. Whitney and Lyle were now finding themselves having to do frequent damage control for the actions of their agents. This

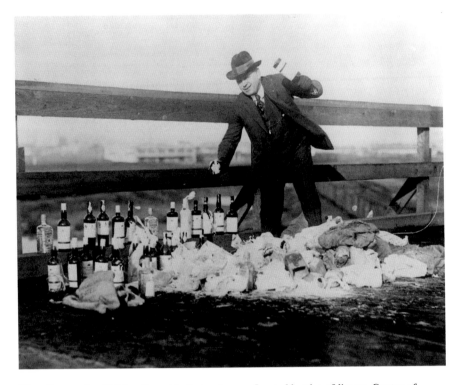

King County sheriff Matt Starwich destroying confiscated bottles of liquor. *Courtesy of University of Washington's Special Collections.*

type of behavior had been encouraged from the beginning so, for many, the proverbial chickens were simply coming home to roost.

On the morning of July 28, 1927, a Tacoma motorcycle cop was dispatched to a vacant schoolyard to investigate a possible domestic disturbance. When he pulled up, Kinky and an unidentified woman were engaged in a loud and drunken argument. When the officer intervened, Thompson became belligerent and threatened the officer. The officer attempted an arrest, and when Kinky reached for something inside his coat pocket, the policeman instinctually drew his gun and fired, shooting Thompson directly on the head. The agent clung on to life for almost a week but finally succumbed to his injury and passed away in a local hospital. Whitney immediately set out to spin the story, blaming Kinky's death on the lawlessness of local bootleggers. Likewise, local temperance figures martyrized Thompson as a respected symbol for the Dry cause.

In October of that year, the second Olmstead trial was set to begin. This trial covered all of Olmstead's criminal activities subsequent to the raid on his

house, to include his arrest at Woodmont Beach. The star witness was none other than Al Hubbard, as he had served as Olmstead's chief lieutenant for much of that time period. Upon taking the stand, Hubbard explained how he had grown tired of "the whole rotten business of bootlegging," which caused him to "volunteer his services as a Federal Prohibition agent." Hubbard then proceeded to describe all of Olmstead's activities in incriminating detail. He explained all the secrets of the bootlegging industry, as well as the entire process of rum-running to a very attentive and fascinated jury. After hearing Hubbard's testimony, the jury only took an hour to reach a verdict. Olmstead was found guilty of all charges, though no additional jail time was added to his four-year sentence, which was to begin immediately. The King of the Puget Sound Bootleggers was finally headed to prison.

After the verdicts were read, Hubbard exited the courtroom and was immediately punched in the face by the wife of a local bootlegger. Other nearby spectators also expressed their hostility to Hubbard over his betrayal of Olmstead and others. Things got so heated that Whitney actually pulled out his gun and threatened to shoot anyone who didn't back off. Hubbard was then escorted to his car by a group of armed guards. After the day's excitement had passed, Olmstead reflected to a local newspaper reporter, "You can't tread on live coals without getting your feet scorched. I know that, always have. And I'm not complaining now. I violated the law. That was always wrong. And now I am going to pay the penalty."

That same month, Frank Gatt stood trial for charges stemming from the Monte Carlo raid. Standing trial with him were several members of the Dry Squad. Whitney was indicting them as co-conspirators on the basis that both parties were aware of Gatt's crimes. This was Whitney's chance to finally bring down all the corrupt Seattle cops who had been such a thorn in his side. The prosecution started things off with the two disgruntled ex-employees who had blown the whistle to the feds. As the prosecution's star witnesses, the two men described Gatt's booze operation to the jury in extensive details. His two previous arrests were brought up, despite the fact that he had been acquitted of all charges. William Whitney was the prosecution's next witness to take the stand, and he explained Gatt's history as the area's top moonshiner as well as his relationship with the Dry Squad, going back to the city's previous mayor, Doc Brown. So far, they were succeeding in their efforts to paint Frank Gatt as a longtime bootlegger and moonshiner, who had enjoyed special protection thanks to a corrupt Seattle Police Department. The defense team had Frank Gatt take the stand and offer his own testimony. Relying on his usual strategy, Gatt explained that he

had sold the Monte Carlo a few years back but no longer had any business interest in the restaurant. "No liquor was ever sold at the Monte Carlo or kept there with my knowledge," he informed the courtroom.

After closing arguments, the jury deliberated the rest of the day but was unable to reach a verdict by the midnight deadline. Deliberations would continue the next morning. The next day, the jury stayed huddled in the deliberation room well into the afternoon. Before a verdict could be reached, however, Frank Gatt surprised everyone by admitting guilt to all the charges standing before him. It was a shocking turn of events but, by doing so, he was no longer obligated to testify about his associations with Edwin Brown and the Dry Squad. Without this incriminating testimony, the Dry Squad was acquitted of all charges. It was an honorable gesture in which Gatt took the sword to protect those who had always looked out for his interests. Frank Gatt was sentenced to eighteen months in prison, which would be served at McNeil Island Penitentiary—the same prison that Olmstead was in. After the sentencing, Gatt told a reporter, "I could tell a wonderful story. I was in the liquor business for years and made a lot of money. I have no definite plans to spill the beans, but I'll have plenty of time to think it over in prison."

A large group of friends, family and followers was there to see Olmstead off to prison, and according to press reports, his final day was filled with "laughter, jests, jokes and smiles." Talking to a local reporter, he echoed the same sentiment that was earlier expressed by Gatt. "Once you are in the liquor game, the price of liberty is treachery. You are caught, and then to gain immunity, you have to turn on your pals. They, in turn, have to squeal on someone else to go free, and so it goes down the line. But I have always refused to pay the price of liberty, and here I am." Upon boarding the prison ship bound for McNeil Island, Olmstead turned and gave one last goodbye to his wife, Elsie. He would soon be joining many of his old friends from the bootlegging fraternity. When he arrived, word of his celebrity had already reached the prison with the top administrators there to personally greet him at the front gate. "I'm sorry," joked the warden, "but we haven't any bartender jobs open just now." Olmstead responded to the quip with his trademark burst of laughter.

THE FINAL DAYS
OF PROHIBITION

I think this would be a good time for a beer.
—*President Franklin Roosevelt, upon signing the Cullen-Harrison Act,*
now celebrated every year as National Beer Day

It was a dark and drizzly December night when Johnny Schnarr steered his speedboat into Discovery Bay. He was landing a shipment of booze and, despite the weather conditions, was vigilant as always. As he approached the landing site, he saw what appeared to be a bonfire thirty yards behind his boat, perhaps coming from a nearby beach. Grabbing his night vision goggles, he was shocked to discover that the fire was actually bioluminescent algae which was being churned up in the seawater by the wake of a Coast Guard cutter only a hundred feet behind him. They had silently been following him for some time and were now looking to trap him inside the bay. Looking closer through his goggles, he could make the name of the ship—*The Arcata*!

Just a few months earlier, Schnarr had built his biggest boat yet, which he had named the *Kitnayakwa*. The new boat was powered by twin four-hundred-horsepower airplane engines which, at that very moment, were about to be put to the test. Immediately upon seeing the Coast Guard cutter, Schnarr hit the throttles, and both engines revved up to a loud, deafening roar as the *Kitnayakwa* flew full speed ahead. *The Arcata* was ready, though, and the machine gunners were ordered to open fire. The entire surrounding bay was suddenly illuminated by bright tracer rounds as the *Kitnayakwa* was hit

by a barrage of bullets. The mood inside *The Arcata* was cautiously jubilant. After so many years, they finally had Schnarr directly in their crosshairs. The *Kitnayakwa* was headed directly toward the head of the bay, with *The Arcata* in swift pursuit, and Schnarr knew that he had to act fast. Between bursts of machine gun fire, Schnarr cranked the wheel as hard as he could, sharply swinging the *Kitnayakwa* around in a tight 180-degree pivot. Before the Coast Guard ship could even register what had just happened, Schnarr was screaming down upon them at thirty knots. He flew past the cutter at full speed, causing a gigantic wake. The machine gunners scrambled to retake their positions, but their ship was bobbing up and down so wildly that they were unable to have any degree of aim, causing their gunfire to uncontrollably spray in all directions. Looking back, Schnarr chuckled at the sight of the flailing gunfire. *The Arcata* attempted to turn around and give chase. By that time, however, it was too late. Schnarr was well out of range of their guns and had, once again, managed a daring escape. Five nearby cutters quickly arrived to assist in Schnarr's capture, but his superior speed was no match for them. He spent the next day making repairs on the *Kitnayakwa*, counting eighteen bullet holes in all. Later that evening, he learned that the Coast Guard was now offering a $25,000 reward for his capture.

Roy Olmstead and Frank Gatt were now both inmates at McNeil Island Penitentiary and tasked with various daily chores such as cleaning up driftwood on the beach and maintaining the vegetable gardens on the island's working farm. The famous prison opened in 1875 and, through the years, would be home to many famous inmates, including Charles Manson and the "Birdman of Alcatraz," Robert Franklin Stroud. It is unknown if Gatt and Olmstead developed any sort of friendship while at McNeill, though the odds are high that the two notorious Seattle liquor men must have crossed paths. If so, their shared experiences with Whitney would surely have represented a shared bond.

During his time there, records show that Frank Gatt was frequently visited by his longtime friend Asahel Curtis, the now famous Seattle photographer who would spend most visits encouraging Gatt to seek the legal route of things when he was finally released. During one visit, the warden even allowed Curtis to snap photographs of Gatt's life inside the penitentiary.

Back in Seattle, Al Hubbard was still working both sides for his own financial advantage. He officially remained working as a Prohibition agent but was also still secretly working in the liquor trade. His years working alongside Olmstead had given him an intimate knowledge of all the movers and shakers in the booze racket. Using that knowledge, Hubbard would

Frank Gatt at McNeil Island Penitentiary. Photo is believed to have been taken by Asahel Curtis. *Courtesy of Jewelli Delay.*

typically join forces with local bootleggers and offer them protection in exchange for bribery money. The idea was that Hubbard would then deliver the money to his fellow agents, and the bootleggers would have their business interests left alone. In reality, the local bureau was completely unaware that such an arrangement had ever been made and Hubbard would pocket the money for himself. In order to account for his "undercover work," Hubbard would give Whitney the locations of these liquor operations but would "tip off" the bootleggers beforehand, so that everyone had time to flee by the time Whitney arrived. This way, both sides felt they were being served by Hubbard, with neither of them aware of his double-dealings.

Other new vice lords were also stepping in. On First Avenue and Virginia, Nellie Curtis purchased the fifty-seven-room Camp Hotel, renovated it with new plumbing, paint and furniture, and opened it as one of the city's most popular brothels. "Naughty Nellie," as she became known, later sold the Camp Hotel and moved her operations over to the LaSalle Hotel near the Pike Place Market. She even had a batch of business cards made up that would be handed out to sailors arriving into town for shore leave and which offered the enticing slogan: "LaSalle Hotel, Friends Made Easily."

In other parts of the city, speakeasies were becoming more popular than ever—likely due to the enhanced efforts of the Dry Agents, which was forcing the liquor trade to operate in a more discreet capacity. Several of these speakeasies operated in the Chinatown district of Seattle. Records show that Olmstead's younger brother, Frank, was still working as the top cop for that precinct and was likely allowing such businesses to operate in exchange for payoff money. By this time, the Bucket of Blood had emerged as the top destination for the city's social elites. Dressed in their finest clothes, locals would descend down the muraled staircase and into the main club area for a night of drinking, dancing and debauchery.

By late 1927, word of Hubbard's activities had reached the U.S. Justice Department. Officials there were alarmed to discover that someone of Hubbard's background had ever been made a Prohibition agent in the first place, or that he was still working as an agent despite the increasing number of allegations concerning his associations with local bootleggers. The whole sordid arrangement begged several important questions. Namely, were Whitney and Lyle aware that Hubbard was suspected of working for both sides? If so, then why did they permit Hubbard to continue working as an agent? Were they also involved in his corruption and, if so, to what extent?

The Justice Department dispatched a team of investigators to Seattle to look into these troubling claims, starting with a look at Hubbard's finances. Despite his paltry income as a federal agent, Hubbard had purchased a fancy sports car and was living in a relatively expensive home. The investigators then took a boat ride over to McNeil Island to pay a visit to Roy Olmstead, who provided them with some shocking testimony. According to Olmstead, he gave the $10,000 he made from the sale of his house to Al Hubbard, who promised Olmstead that the money would go toward purchasing the "good will" of Whitney and Lyle. This was prior to Olmstead's second trial in which he reasoned that enough payoff money could possibly help him avoid any prison time. Of course, things did not end up working out that way. But what had happened to the money that Olmstead claimed he had given Hubbard? Did Hubbard double-cross his old boss and keep the money for himself, or had Whitney and Lyle accepted the payoff money? The investigation seemed to be uncovering more questions than it answered. In the meantime, Hubbard was placed on suspension by the Prohibition Bureau and was no longer authorized to continue working as an agent in any capacity. Unfazed, he simply used his underworld connections to continue on as a bootlegger.

In winter of that year, Hubbard and a crew of men were in the middle of unloading 150 cases of liquor up near Port Townsend when they were

surprised by the local sheriff and a few of his deputies. Jefferson County sheriff Phil Chase was known in the area as "the scourge of the Volstead violators" due to his tenacious pursuit of bootleggers and moonshiners. He was a vocal supporter of local temperance groups and would donate any confiscated moonshine stills to the local WCTU chapter so they could earn money from the recycled copper. Upon seeing the crates of booze, Sheriff Chase ordered his deputies to place all the men under arrest. Thanks to some quick thinking, Hubbard pulled the sheriff aside and produced some of his old federal credentials, falsely explaining that he was a Prohibition agent and that this was all part of an undercover operation. He was convincing enough in his story that the sheriff let the men go along with their entire shipment of booze.

In city hall, Bertha Landes was running for reelection in the 1928 mayoral races. She had done a fairly good job of restoring some semblance of order to a lawless city, but, once again, the pendulum had swung back in the opposite direction as Seattle had grown tired of Prohibition laws. As a result, Landes lost her reelection bid in favor of "Wet" candidate Frank Edwards, who was voted in as mayor. The old days of Hiram Gill and Doc Edwards were back once again.

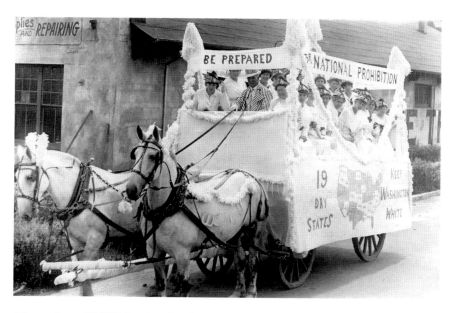

A horse-drawn WCTU float in a Seattle prohibition parade. The "Keep Washington White" sign seen on the side of the float is in reference to the color white being the symbol of purity from alcohol. *Courtesy of Washington State Historical Society.*

Frank Gatt was granted an early release from McNeil Island, in 1929, due to good behavior. He immediately went back into moonshining, setting up large-scale stills in Renton, Tacoma and Lake Washington. There were even reports of Gatt opening up an illegal nightclub up in Port Townsend, complete with booze, gambling and live jazz bands. Rumors at the time held that Hubbard was involved in this operation as well, using the nightclub as a place to sell narcotics. Despite the nightclub, Gatt primarily stayed close to his Rainier Valley home in order to tend to his various stills. Seattle still had an unquenchable thirst for booze and, before long, Gatt was back to making good money. He needed a business front, though, and so purchased the Universal Cigar Store near the King Street Train Station. The cigar store now allowed him to present himself as a legitimate business owner. Unfortunately, word about his moonshining stills had attracted the attention of the local Prohibition office.

One day, Gatt was leading a small caravan of vehicles on a delivery run. The plan was to load up the cars with hundreds of gallons of moonshine and then drive it down to Tacoma. After loading up, Gatt noticed they were being followed by what appeared to be federal agents. A chase ensued, with the two sides exchanging gunfire at high rates of speed. Gatt and his crew managed to get away, though his brother, John, was hit by a stray bullet. They were able to get him to a hospital in time, saving John's life. Unfortunately, the injury left his brother crippled and in a wheelchair for the rest of his life. The guilt over the incident would haunt Frank for the rest of his life.

Consolidated Exporters was still sending motherships full of booze down to the Haro Strait, just outside of U.S. territorial waters, where they would anchor and wait for their American customers to arrive in speedboats. However, in 1930, the Canadian authorities finally caved in to pressure from the American government, and new shipping laws were introduced so that any Canadian ship carrying liquor had to stay at least forty miles off the U.S. coast. This meant that any motherships now had to station themselves out in the open seas of the Pacific Ocean rather than the convenient closeness of the Haro Strait.

For Johnny Schnarr, this meant that he would now need a new ship capable of these new ocean voyages. Consolidated Exporters loaned him money for this new boat, as he was one of its top smugglers. The new boat was fifty-six feet long and boasted two 860-horsepower Packard Liberty airplane engines with top speeds of up to forty knots while fully loaded with 250 cases of booze. The biggest innovation was that the exhaust pipes were muffled and ran under the boat so the vessel was very quiet. He named it the *Revuocnav,*

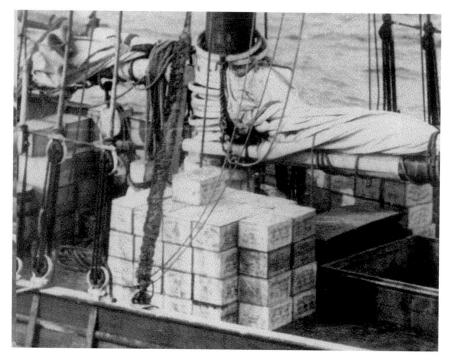

The deck of a Canadian mothership loaded full of crates of booze. During Prohibition, these ships would act as floating warehouses that American rumrunners would rendezvous with to purchase liquor. *Courtesy of Coast Guard Museum Northwest.*

which is Vancouver spelled backwards. Other rumrunners at the time were starting to install bulletproof steel plates on the pilothouses of their boats due to the aggressive tactics being used by the Coast Guard.

In the early part of 1930, the Justice Department concluded its investigation of the Al Hubbard corruption case. As was suspected, evidence pointed to illegal behavior on the part of assistant director William Whitney. Investigators presented their findings to a grand jury, which alleged that Whitney had accepted bribes from various bootleggers, including Olmstead, in exchange for legal protection. Further evidence pointed to Hubbard being hired as an agent in order for Whitney to use him as a go-between with the area's top liquor men. The resulting grand jury trial became known as the Whitney Graft Case. At the heart of the indictment was Hubbard's sworn statement that he had arranged wide-scale bootlegging activities at the financial behest of William Whitney. This was considered to be flimsy testimony, though, as Hubbard's credibility was questionable at best. Other bootleggers and underworld figures were also brought in to testify against Whitney.

In one of the trial's more surprising moments, the doors of the courtroom opened up and in walked Roy Olmstead from McNeil Island, flashing his trademark smile as he strode up to the witness stand. The exact nature of his testimony has never been revealed, but it's generally accepted that whatever he told the jurors was probably less-than-flattering toward Whitney. Once again, it appeared as though Olmstead was having the last laugh in his ongoing battles with the assistant director. Out in the hallway, Olmstead pointed to the newly completed Northern Life Tower and remarked to gathered reporters, "Some building! Hadn't seen it before. Been out in the sticks, you know."

The trial was excitedly covered by all the local papers, with the driving narrative being that Whitney had been more responsible for Seattle's supply of illegal booze than any of the top bootleggers, many of whom were now serving time at McNeil Island. After nine days, the jury found Whitney to be innocent. Despite the verdict, the damage inflicted upon the reputations of William Whitney and Roy Lyle was irreversible, especially in the court of public opinion. Whitney, in particular, had become the symbol of Seattle's discontent with Prohibition. To many, he represented all the violence, corruption and brutality that had become associated with the local Prohibition office and which was now being widely discussed in the local papers. On May 27, 1930, both Whitney and Lyle were formally dismissed from the Treasury Department's Prohibition Bureau. Their history of deceitful tactics had finally now worked against them. A bitter and angry Whitney returned to his private law practice and, in an ironic twist, was known to have legally represented accused bootleggers.

By 1931, with Whitney and his team of overzealous agents now gone, the streets of Seattle saw an upswing in the number of illegal speakeasies. Despite Whitney's absence, the new heads of Prohibition were set to make sure that liquor laws were still being enforced. The Fern Apartments near the Pike Place Market was their first target. Upon busting down the front doors, agents were shocked to discover that two entire floors of the apartment building were devoted to the manufacture of booze. One of the floors was an elaborate brewery set up for making beer, and the other floor was dedicated to making moonshine. In one of the floors below, a full-scale bar had been set up for customers to mingle while enjoying their beverages. In all, 2,000 quarts of beer, 180 pints of gin and 20 gallons of moonshine were seized in the raid.

A month later, agents hit the infamous Bucket of Blood, using sledgehammers to knock down the heavily barricaded front door. Downstairs

in the club area, the live jazz was so loud that none of the guests were even aware that a raid was taking place. Unable to get anyone's attention, one of the exacerbated agents finally walked over to the stage and slapped handcuffs on the piano player, followed by a systematic roundup of all the inebriated and well-dressed guests inside. Over a hundred arrests were recorded that night. The next day, the *Seattle Star* ran the headline, "SOCIETY FOLK ARE CAUGHT IN ROUNDUP!" It was noted that agents had found a secret exit to the back alley, though they were unaware if anyone had used it to escape. Following the raid, the Bucket of Blood was shuttered up and the space would remain vacant for over eighty years until being rediscovered in a 2018 building restoration.

The same year, Roy Olmstead was released from prison at the age of forty-seven. Upon arriving to a Seattle wharf after being dropped off by the prison boat, he quipped to his wife, "This is certainly better than going the other way." He was penniless and in major debt to the IRS from all his earnings as a bootlegger that he had never paid taxes on. Despite Olmstead's being in the penitentiary for only four years, the city had changed remarkably. Both his friends and enemies were mostly now gone, with a whole new cast of characters taking their places. All of the old locations, familiar faces and good times had vanished during his time at McNeil. The city had moved on, and very few people remembered who the King of the Puget Sound Bootleggers even was. Those who did remember speculated if Olmstead would return to his old ways. Unlike Frank Gatt, however, Olmstead had spent most of his incarceration in the prison library, where he studied religion and philosophy. During these studies, Olmstead developed a fascination with the moral teachings of the Church of Christ, Scientist, eventually becoming a convert. It was a somewhat odd and unpredictable turn of events, especially given his past. But Olmstead clung closely to this new belief system and emerged from prison as a man dedicated to doing good.

His first few years out of prison were difficult. Olmstead and his wife, along with their two daughters, lived in a series of cheap apartments while he earned a meager income working for a pest control company. In 1934, he went to work as a salesman for Standard Furniture Company while still doing exterminator jobs on the side. The next year, in 1935, he received a presidential pardon and was thus exonerated of all his previous crimes. In his free time, Olmstead would return to McNeil Island and offer his spiritual services to the inmates inside. By this point, it had become clear to everyone that Olmstead's days in the liquor trade were officially over and his name eventually stopped appearing in the public record. Many

The stairway murals leading down to the fabled Bucket of Blood speakeasy, which was recently discovered during a building renovation in Seattle's International District. *Photographs by Madeline Holden.*

of the city's older residents remembered him from his days as the area's top bootlegger, but for many he was simply known as a friendly furniture salesman with a hearty laugh.

On the national stage, Franklin Delano Roosevelt had become the official Democratic nominee for the upcoming presidential elections. President Herbert Hoover, his Republican opponent, was running for reelection in a year where the Great Depression had brought the entire country to its knees. Prohibition had also become an important issue, as liquor laws had become increasingly unpopular with a growing national demand for repeal of the Eighteenth Amendment. For many Americans, Prohibition represented government overreach, increased crime and reduced tax revenue. The Republican side favored existing Prohibition laws but, sensing its unpopularity amongst the voters, endorsed a new system whereby each state could determine if it wanted to be wet or dry. The whole issue was tricky terrain for the Republicans as they were still under the heavy influence of groups such the Anti-Saloon League.

The Democrats wanted the whole thing scrapped and made their goals abundantly clear at that year's Democratic National Convention when they presented their official plank: "We favor the repeal of the Eighteenth Amendment. Pending repeal, we favor immediate modification of the Volstead Act to legalize the manufacture and sale of beer and other beverages of such alcoholic content as is permissible under the Constitution and to provide there from a proper and needed revenue." In response, President Hoover declared: "Our opponents pledge the members of their party to destroy every vestige of constitutional and effective federal control of the liquor traffic. That means over large areas the return of the saloon system. I cannot consent to the return of that system." The battle lines over this issue had been officially drawn and, while out on the trail, Roosevelt's official campaign song, "Happy Days Are Here Again," reinforced his anti-Prohibition views to crowds of excited supporters. It was an exciting year of politics but, in the end, "stamp out Prohibition" became a more popular rallying cry than the "Stay Dry" pleas of temperance supporters, and Roosevelt won the election in a landslide victory.

In Seattle, buoyed by Roosevelt's victory, the city developed a robust anti-prohibition movement. Just as the Seattle temperance movement held a series of popular parades two decades earlier, the Wets were now hosting large-scale events throughout the city. In 1932, a downtown "Bring Back Beer" parade drew several thousand onlookers. Once again, the pendulum had swung back in favor of legal alcohol. Despite this public sentiment, local

dry agents were still tasked with enforcing these laws. Down by the old Bay View Brewery, longtime brewer Alvin Hemrich had established the Hemrich Brewing Company, which he set up in anticipation of the Eighteenth Amendment being repealed. In the meantime, he used the brewery to make near beer, as well as the production of malt and wort, which were being used by home brewers to make their own beer. Laws at the time stipulated that near beer must have less than half of 1 percent alcohol by volume. However, Hemrich didn't always adhere to these laws. This, along with the amount of wort he was openly selling to home brewers, drew the attention of federal agents, who raided his brewery and arrested Alvin and his eldest son, Elmer. In an interesting twist, they hired William Whitney to represent them in court. The Hemrichs were subsequently acquitted of all charges, likely due to political climate of that time. The incident would serve as the last major liquor bust in the entire state.

In November of that year, Washington State residents headed to the polls to vote on Washington State Initiative 61, which, if passed, would repeal all state liquor laws. The Eighteenth Amendment had not yet been repealed, and national law always holds power over state law. So the initiative was seen as more of a mandate to support the repeal of the amendment. By a huge margin, Initiative 61 passed, with voters making it clear that they were ready for alcohol to be decriminalized.

In March 1933, Congress ratified the Volstead Act and enacted the Cullen-Harrison Act, named after its Democratic sponsors, which permitted the sale of beer and wine of up to 3.2 percent ABV. President Roosevelt signed

A "Vote Yes" for Washington State Initiative 61 pinback from 1932. This initiative effectively repealed all state prohibition laws. *Author's collection.*

the act the following day, making it official law. Upon signing this act, Roosevelt made his famous quip, "I think this would be a good time for a beer!" However, only states which had already repealed their dry laws were legally permitted to begin selling beer. Here in Washington, as a result of Initiative 61, such beer was immediately available for purchase. True to his vision, Alvin Hemrich was ready for such an occasion, and the Hemrich Brewing Company would be the first Seattle brewery to begin selling legal beer to the public in over seventeen years. In what became known as New Beer's Eve, throngs of thirsty Washingtonians gathered

Infamous rumrunner Johnny Schnarr in his later years. *Courtesy of Coast Guard Museum Northwest.*

outside breweries and taverns for their first legal beer in almost two decades. In Seattle, the first drink was served at midnight on April 7 at a bar just off Fourth Avenue. By noon the next day, the entire city had completely run out of beer. To this day, the passage of the Cullen-Harrison Act is celebrated every year on April 7 as National Beer Day.

While people throughout the country were enjoying beer once again, Roosevelt and the Democratically controlled Congress were busy passing the Twenty-First Amendment to the Constitution, which was set to repeal the previous Eighteenth Amendment. The proposed amendment was adopted by Congress on December 5, 1933, and signed by the president on that same day. Prohibition had been officially repealed and alcohol was now legally available once again. The so-called great social experiment was officially over and, as Roosevelt's campaign song had earlier promised, happy days were here again.

Soon after, Johnny Schnarr made his last liquor run as a professional smuggler. He was one of the only rumrunners to have never been caught, despite the hefty reward for his capture. He had been smart with his money and was able to buy a nice waterfront house where he spent the rest of his days quietly enjoying life as a commercial fisherman. It was rumored that he kept one of his old rum-running boats, with locals occasionally catching sight of an aging Schnarr reliving his glory days out in the waters of Puget Sound.

PROHIBITION'S LEGACY

Protect the welfare, health, peace, morals and safety of the people of the state and help minimize the evils connected with the liquor traffic.
—*Original mission statement of the Washington State Liquor Control Board, formed in 1933*

The repeal of the Eighteenth Amendment resulted in the immediate demise of Consolidated Exporters. Its product and services were no longer needed now that alcohol was once again legal in the United States. One of the company's top motherships was en route to its ocean destination when the captain received word that the entire company had just officially closed business. In the ship's hold were fifty-four thousand cases of liquor. Most of the crew held out hope that someone, somewhere would want to purchase such a large haul of liquor but, in the end, there were no interested parties. More importantly, there was no more Consolidated Exporters. It had always been run as a quasi-legal operation and so the owners simply just walked away and vanished. What happened to their remaining inventory of booze is unknown, but many of the company's rumrunners, land agents and crew members were left unpaid, so it is fair to speculate that the abandoned employees took any remaining inventory left in the company's warehouses and ships. Further, because the officials at Consolidated Exporters had gone to such great lengths to not leave any paper trail and keep everything off the official record, there was no legal recourse for the remaining employees to collect any wages owed to them. The motherships were mostly sold off

for parts, with one of the ships being used as a logging ship before sinking somewhere in the Puget Sound after hitting a reef in a patch of dense fog. In due time, all the company ships, crew members and rumrunners faded from the public's memory.

In Washington State, legislators were caught unprepared by the repeal of the Eighteenth Amendment, as there were no existing laws mandating how alcohol should be regulated. More importantly, legal alcohol now represented potential tax revenue, so this was a matter that required urgent attention. A special session was called, and the Liquor Control Act was passed to control the sale of liquor. As a result, a three-member Liquor Control Board, appointed by the governor, was set up in order to protect "the welfare, health, peace, morals, and safety of the people of the state." The sordid legacy left behind by pre-Prohibition saloons was still a worrisome aspect for many state residents, so the board—which saw its mission as promoting "true temperance"—went out of its way to ensure that Washington State would avoid "the evils connected with the liquor traffic" and would never return back to the lawless days of the saloon. Since hard liquor had been so abundant during Prohibition, the board took a hard stance against it. As a result, taxes on beer were kept low, but taxes on liquor were intentionally set high. Keeping a careful eye on alcohol content, the board also implemented a rule where wine and beer could be no higher than 3.2 percent ABV.

Lastly, the board also set up a system whereby hard alcohol could only be purchased in state-run liquor stores, while allowing the private sale of beer and wine in general stores. These state-run liquor stores stayed in place until voters approved the privatization of hard booze in 2011. The first few alcohol stores opened in March 1934, with forty-six more opened by the year's end. Their prices were kept intentionally low in order to put any remaining moonshiners out of business. Inside these liquor stores, clerks were forbidden to discuss the merits of different brands, nor could they suggest one alcohol variety over another. They could not even inform the customer what brands they carried, rather a printed list was provided for customers inside each store. Upon a customer making a purchase, the bottle was placed inside a brown paper bag and the customer was sent along his or her way.

The other pressing issue facing the board concerned rules being implemented for drinking establishments. Because the word *saloon* still had such a negative connotation, these new drinking establishments would be known as taverns. However, state regulators wanted to make sure that this new crop of taverns didn't become a public menace the same way that saloons

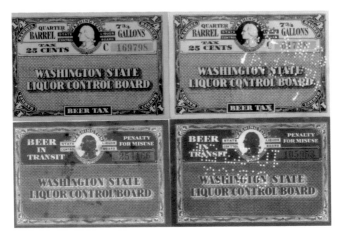

Collection of beer tax permits issued by the Washington State Liquor Control Board after the repeal of the Eighteenth Amendment in 1933. *Author's collection.*

earlier had, so strict rules were put into place which were zealously enforced by a team of agents. Number one, drinking establishments could not sell any hard liquor, and any wine or beer could be no higher than 3.2 percent ABV. Other rules reflected the general concerns people had about avoiding the lawlessness from previous times, including prostitution. Therefore, women were no longer allowed to stand at the bar nor could they order drinks for themselves. In addition, they had to be seated at all times so there could be no possibility of solicitation. This particular rule would stay in effect until 1969! The board also implemented a series of rules to avoid the bawdy and indecent reputations associated with prior saloon culture, including that no vulgar or profane language could be used while inside a tavern. Additionally, there could be nothing indecent on the walls, and the interior of a tavern had to be visible from the street in order to minimize the risks of any illicit behaviors. To further keep things tame and in proper order, drink specials, happy hours and free food were not permitted, and closing time could be no later than 1:00 a.m. Customers were required to be seated while drinking, as walking around or standing with a drink in your hand was now against the law. The board's puritanical approach even extended to the type of furniture permitted inside a tavern, as there could be no booths and any partitions between tables could be no higher than forty-two inches. These particular rules were likely the result of the legacies leftover from the boxhouse days.

When it came to advertising, the board encouraged "conservative and dignified advertising," and newspaper ads were forbidden to show anyone actually consuming alcohol, nor were they allowed to use the word *saloon*. Naturally, Washington State blue laws were still on the books, so neither taverns nor state-owned liquor stores could open on Sundays. The first

tavern to be approved by the Washington State Liquor Control Board was Thomas McClanahan's Beer Parlor, which opened up on Broadway Avenue in the Capitol Hill neighborhood. The following year, it changed its name to the De Luxe Tavern. Today, the popular drinking establishment is better known as the DeLuxe Bar and Grill, though few of its customers are likely aware that this was the first tavern to open in Seattle after Prohibition was repealed.

Down in Tacoma, Pete Marinoff finally lived up to his nickname and established a "legitimate" business when he opened the Northwest Brewing Company in an old Tacoma meatpacking plant. Marinoff had always been a shrewd businessman, so when Prohibition ended, he had a plan in place to switch over to the new legal booze market. The brewery was ideally located near a railroad stop, which was perfect for distribution. Before long, the brewery was producing ample quantities of Marinoff beer, making it one of the top beverage choices in the Tacoma area. Delivery trucks with the Marinoff beer logo on the side were a common sight on local roads, and the brewery provided hundreds of jobs for nearby residents.

During this time, the Teamsters Union, under the leadership of Seattle's Dave Beck, had negotiated an agreement with all Western Washington breweries, in which Teamster members would be the designated delivery drivers. This included the Northwest Brewing Company, and, at some point, things went sour, with the Teamsters accusing Marinoff of contract violations. Unable to reach a compromise, a strike was then called, with over a hundred Teamster members picketing in front of the brewery. In response, Marinoff used drivers from the Brewery Workers—a competing union—to deliver his beer. This required the Brewery Workers to drive

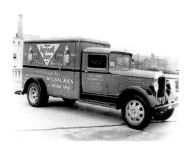

Marinoff's trucks through the picket line, and things quickly became volatile between the two sides. On May 24, 1935, an armed conflict broke out as the delivery trucks were attempting to drive through the picket line. Brewery Workers drivers were pulled from their trucks and in the violent melee that followed, one of the picketing Teamster members was fatally wounded. On the basis that his business decisions had deliberately led to the man's death, Marinoff was charged with and convicted of second-degree murder and sentenced to

A delivery truck for Tacoma's Northwest Brewing Company, founded by Pete Marinoff following the repeal of Prohibition in 1933. *Courtesy of BreweryGems.com.*

twenty years in prison. At the last minute, his conviction was overturned by the Washington State Supreme Court. Despite avoiding a hefty prison sentence, ensuing legal troubles resulted in Northwest Brewing Company being forced into bankruptcy, and it went out of business. Soon after, Marinoff moved down to California to escape all the lingering hostilities left over from the tragic incident.

Despite the repeal of Prohibition laws, Frank Gatt was continuing to manufacture moonshine. It was a trade that he learned well, and his product was so famously good that he had managed to retain a loyal customer base. His largest distillery was being operated on the Fred Howard Ranch down near Renton. However, the repeal of the Eighteenth Amendment didn't make his business any more legal than it was during Prohibition. In the eyes of the government, his biggest transgression was that he had not been paying any taxes on such a profitable business, and on August 19, 1935, IRS agents raided all of his moonshining facilities. At the ranch, several hundred gallons of illegal hooch were discovered and Gatt and his men were arrested on the spot. Charged with tax evasion, Gatt was found guilty and sentenced to seven years in prison and a $5,000 fine. Once again, Frank Gatt found himself back behind bars at McNeil Island Penitentiary, where he stayed until 1937. Following his release, Gatt finally began working a legal job as a home improvement contractor, helping to build new homes in his Beacon Hill community.

With new WSLCB rules now in place, Washingtonians couldn't legally buy hard alcohol by the drink until the late 1940s as taverns and bars were only allowed to sell beer and wine. This led to a rise in "bottle clubs," in which paid members would bring their own bottle of booze to dance clubs and restaurants. In turn, these establishments would offer a wide array of mixers, such as sodas, fruit juices and sparkling water, allowing the customers to mix their own drinks at the table. It was a clever way to bypass state liquor laws, though such clubs were declared illegal in 1946. Afterwards, many of these clubs operated outside city limits and away from the jurisdiction of the Seattle police. This led to a proliferation of roadhouses, many of which had been in operation since Prohibition. The Liquor Control Board had a small army of one hundred agents to enforce its rules and would frequently lead raids at any clubs suspected of allowing customers to bring booze inside, though it was difficult to enforce as people would simply hide their bottles if law enforcement walked through the door.

All of this came to an end on November 2, 1948, when Washington State Initiative 171 was passed, approving the sale of liquor by the drink. Any

establishment wishing to sell hard liquor by the drink needed a Class H license, for which nearly a thousand applications were filed in less than a month. The board recommended several rules and guidelines with respect to these Class H licenses, including that gambling be prohibited and that any restaurants must garner a certain percentage of their income from food sales. To prove its culinary legitimacy, any establishment with a Class H license needed to serve at least four "complete" meals (appetizers didn't count) and have adequate refrigeration, an oven, a grill, and a broiler. Additionally, the board mandated that any establishment selling liquor must not have any windows or open doorways on the basis that consumption of hard alcohol was an indecent act that should not be viewed by the general public. In Seattle, the circus-themed Carousel opened as Seattle's first cocktail lounge and, in keeping with the law, it had no windows.

These rigid state liquor laws remained in effect though the 1950s until they slowly started loosening. In 1960, the word *cocktail* was finally allowed to be used in advertising, and in 1962, the Seattle World's Fair further expanded the level of permissiveness offered by the board, as a number of Class H licenses were granted to a number of establishments on the fairgrounds where entertainment, music and dancing were offered to visiting tourists.

In 1966, Washington State Initiative 229, also known as the Repeal of the Sunday Blue Laws Initiative, was voted into law which repealed the so-called blue laws that had been enacted in 1909 and which prohibited liquor sales on Sundays. The measure passed 604,096 to 333,972 and, in response, the board agreed to begin allowing Class H establishments to sell liquor during certain hours of the day on Sundays and on Saturdays until 2:00 a.m. A few years later, in 1969, the Washington State Legislature repealed certain other former liquor laws that forbade people from drinking while standing up and single women from being able to sit at the bar and order drinks. At long last, the same year as the moon landings, Washington State women were finally allowed to legally order a drink for themselves

Menu cover for the Carousel, Seattle's first cocktail lounge to open after Prohibition was repealed. *Author's collection.*

The 1970s continued to see some erosion of state liquor laws when the sale of liquor

on Sundays was extended to midnight and, in 1976, the board repealed the previous regulation that prohibited alcohol from being served in view of the public. When this happened, Carousel became Oliver's, Washington State's first "daylight" cocktail bar to feature windows.

It wasn't until 1982 that the board finally allowed Washington State breweries to begin making and selling beer with an alcohol content higher than 3.2 percent. This opened the doors for the craft beer movement to take hold, starting with Bert Grant's Brewery Pub in Yakima, which was the first brewpub to open in the United States since the repeal of Prohibition. Taking advantage of the region's thriving hop farms, Grant was among the first to introduce American palates to the hoppy flavors of India Pale Ale, which has since become one of the defining beers for craft breweries.

In Seattle, Gordon Bowker set out to establish a similar brewery in an old Ballard transmission shop with the goal of "brewing Seattle a better beer." Bowker had his start in the local beer market back in the 1970s when he helped Rainier beer create a series of famous television commercials. Later, he cofounded a local coffee company named Starbucks that would revolutionize the way the world viewed and drank coffee, and now he was attempting to do the same thing with beer. Together with Paul Shipman as the marketing ace and veteran Rainier brewmaster Charlie McElevey, the new brewery introduced its namesake Redhook Ale to the Seattle market in August 1982, helping cement Seattle's role in the craft beer revolution.

Most recently, the last of the Liquor Control Board's original draconian rules were overturned in 2011 when state voters approved State Initiative 1183, which privatized the sale of hard alcohol. State residents could now buy hard alcohol in regular grocery stores rather than state-owned liquor stores. The jolt from the privatization initiative further led the state legislature to loosen rules governing distilleries and the manufacture of hard spirits, creating a craft spirits boom, similar to what happened to beer and wine a couple of decades prior. Lastly, the recreational use of marijuana was legalized in Washington State in 2012. The board was assigned the task of regulating this new legal cannabis industry, and on July 24, 2015, it officially changed its name to the Washington State Liquor and Cannabis Board. While the wild days of the saloon are now a long gone memory, the public's views on alcohol and other intoxicants seem to have come full circle, as such vices are not only now tolerated but packaged and sold as luxury items to a growing base of appreciative connoisseurs.

EPILOGUE

On a cold February morning in 2018, a small crew of Seattle construction workers was clearing space inside the Louisa Hotel when the men accidentally stumbled upon an unknown room with mysterious images on the wall. The historic building had been vacant since a devastating fire gutted over half of its interior in 2013 and was now in the process of an ambitious renovation project. One of the workers shone his flashlight up a dark stairway, revealing an expansive collection of colorful murals painted along the decaying walls. The murals were clearly from another era, as they depicted smiling men in top hats and tuxedos accompanied by laughing women in flapper dresses and fur-trimmed coats. The building's owner was immediately notified, and it quickly became apparent that something historically significant had just been discovered. Various experts were brought in to examine the space and, based on the condition of the walls and the clothing of the people, it was estimated that the murals had likely been painted in the 1920s, during the Prohibition era. Beyond that, it was unknown what this space had been used for.

A small news article about the exciting discovery caught my eye during the research phase of this book. A few days later, while digging through a box of Prohibition-related documents at the National Archives, I stumbled upon a cache of articles about the fabled Bucket of Blood speakeasy that had been raided and shut down in 1931. I was well aware of this notorious drinking spot, so I was excited to find such a trove of information about it. As I read through the documents, the descriptions that were given sounded

remarkably similar to what had been briefly described in the news article. Quickly sifting through the articles, my suspicions were confirmed when I managed to find an address listed for the famous speakeasy which, indeed, matched the address of the mysterious space recently uncovered at the Louisa Hotel. After sitting shuttered and vacant for over eighty years, the Bucket of Blood had re-emerged from the depths of local history and was making its presence known once again. As of the date of this writing, the owner of the building is working hard toward the preservation and restoration of these stairway murals in the hopes of establishing the notorious speakeasy as a historical site.

The exciting discovery of the Bucket of Blood represents a fascinating period of Seattle history in which a war of questionable morality played out across the city streets: the Wets vs. the Drys, Open Town vs. Closed Town, temperance groups vs. the saloons, the bootleggers vs. the Prohibition agents, the Coast Guard vs. the rumrunners. In short, it was a hard-fought battle in which the forces of virtue took on the purveyors of vice, with no clear winners or losers. The "great social experiment" ended abruptly in 1933, though the destinies of the people involved in its story were profoundly changed forever.

Roy Olmstead spent the remainder of his life dedicated to the Christian Science beliefs he adopted while incarcerated at McNeil Island. Records show his wife, Elsie, filed for divorce in 1943 citing "abandonment." Other sources cite religious differences as the cause of the split. Whatever the reason, Olmstead remained in Seattle as a full-time advocate for Christian Science, visiting jails and prisons in an attempt to rehabilitate the inmates inside. He refused lucrative job offers from liquor distributors and even a popular nightclub, and his last years were spent living a very meager and humble existence. He died on April 30, 1966. He was seventy-nine years old. The obituary for the man who was once the beloved King of the Puget Sound bootleggers was buried toward the back of local newspapers without much fanfare. His legend and folk hero status were almost forgotten until being revived in the 2011 Ken Burns docuseries on Prohibition. Most recently, a bronze and stone plaque was permanently installed in his honor at Woodmont Beach in Federal Way. This monument is named "Old Roy" and overlooks the ruins of the old Woodmont Dock—the site of his famous arrest on Thanksgiving Day in 1925.

In 1925, a man by the name of Birt Fisher purchased Roy Olmstead's radio station, KFQX, which the bootlegger was forced to sell in order to help pay for his mounting legal costs. Fisher immediately changed the call

sign to KTCL, for "Know The Charmed Land," as he didn't want the station to have any link to the previous liquor trade. Later, he would change the call sign to KOMO, which still operates as a popular radio and television station to this day.

Frank Gatt's beloved wife, Lucretia, died in 1951, and he found himself overcome with grief. He had been sober for many years but resumed drinking to help deal with the emotional pain. Guilt over his brother's paralyzing injury still haunted him as well. One cold night in 1955, he was found alone out in the rainy streets, drunk, incoherent and inconsolable. He was brought to a local Seattle hospital but developed pneumonia and died a lonely, heartbroken man at the age of seventy. It is a sad and tragic end to a man who was once one of the most well-respected members of his community and who ran one of the biggest moonshine operations in Washington State history.

Johnny Schnarr spent the remainder of his post-Prohibition career as a commercial fisherman before retiring in 1969. He lived well into his nineties, though the exact date of his death is unknown. In reflecting back on his life as a rumrunner, he always lamented over the fact that his collection of photographs showing his various rum-running boats had gone missing. It is unknown if these photographs were destroyed or are sitting in an attic somewhere, waiting to be discovered. Many feel that his innovative boating designs were revolutionary in the speedboat industry, and it's certainly no coincidence that locations where rum-running was prevalent (Detroit, Seattle, Florida) have since become popular hubs for hydroplane racing. It has been often speculated that hydroplanes races evolved from the thrilling experiences of rumrunners making deliveries in their boats, similar to NASCAR racing having evolved from bootleggers using souped-up hot rods to evade law enforcement vehicles. In Seattle, hydroplane races began in 1950 as part of the annual Seafair Festival.

Al Hubbard's post-Prohibition story was just as exciting and mysterious as his early years. After the Eighteenth Amendment was repealed, Hubbard joined the merchant marines for a few years. After that, his story reads like a Hollywood movie. According to various accounts, Hubbard was recruited into the Office of Strategic Services (the precursor to the CIA) due to his natural talents for electronic communications. At one point, toward the end of World War II, Hubbard was reportedly involved in the Manhattan Project. From there, he moved to Canada and became a self-made millionaire after founding his own charter boat company. By 1950, he was appointed as scientific director of the Uranium Corporation of

Vancouver. He lived on a private Canadian island in the Haro Strait with his own hundred-foot yacht.

By the 1950s, however, Hubbard had become intellectually restless and was looking for something else to satisfy his scientific curiosities. One day, while reading though a scientific journal, Hubbard stumbled across an article about a new hallucinogenic compound called LSD. He soon obtained some, and the profound experience left him a lifelong convert. Excited by this new discovery, Hubbard made it his mission to share the substance with other important thinkers. In all, he shared the hallucinogenic properties of LSD with over six thousand people before it was effectively banned in 1966. During these psychedelic journeys, he explored the roots of alcoholism with Alcoholics Anonymous founder Bill Wilson, and famously introduced LSD to Aldous Huxley, as well as supplying most of the Beverly Hills psychiatrists, who, in turn, turned on actors Cary Grant, James Coburn, Jack Nicholson, novelist Anais Nin and filmmaker Stanley Kubrick. As a result, Hubbard became known as the "Johnny Appleseed of LSD."

By the 1970s, Hubbard's psychedelic pursuits had exhausted his financial resources and he was forced into semi-retirement. In one of his last noteworthy acts, Hubbard advocated for a law allowing LSD to be administered to terminal cancer patients. This proposed law never came to pass, and Hubbard retired to a small mobile home in Casa Grande, Arizona. He peacefully passed away at the age of eighty-one on August, 31, 1982.

William Whitney continued to work as a local attorney until suffering a disabling stroke in 1938, likely the result of a lifetime cigarette habit and years of heavy drinking. The stroke left him paralyzed. He died on October 8, 1940, at the age of sixty-three.

A year later, Whitney's political archrival, Edwin "Doc" Brown, suffered a heart attack and passed away in his Capitol Hill home on July 28, 1941. He was seventy-six years old.

Popular speakeasy owner Doc Hamilton served time in prison alongside Roy Olmstead as part of the Whispering Wires trial. Hamilton was eventually pardoned of his crimes, though he was never able to reestablish his former success. In 1942, he died alone in the Mar Hotel in Seattle's Chinatown district.

After Pete Marinoff left Seattle for California, he became an executive at an insurance company. He remained largely off the record, though he was involved in a high-profile lawsuit in the 1980s. He lived into his nineties, though the date and cause of his death are unclear.

The Reverend Mark Matthews continued to lead the church he helped to create until his death in 1940. Following the end of Prohibition, he helped create such local institutions as the Harborview Medical Center, as well as other branches of his church, including the University Presbyterian Church, which continues to be a major institution to this day. A statue of Matthews, in honor of his contributions, can be found in Seattle's Denny Park.

After his trial for murder, in which he was acquitted of all charges, Seattle boxhouse king John Considine reinvented himself as a respectable impresario, establishing Seattle's first movie theater. Soon after, Considine used the "entertainment" experience he had learned from his boxhouse days and established the first vaudeville circuit in the world, with theaters in Vancouver, Portland, Bellingham, Everett, Spokane and Seattle. At some point, Considine made the friendship of Tammany Hall boss "Big" Tim Sullivan in New York City, and the two men joined together to form the famous Sullivan-Considine Vaudeville Circuit, spreading the popularity of vaudeville to the rest of the country. Soon after, the advent of moving pictures spelled the end of vaudeville, and Considine moved down to Los Angeles to gain a foothold in the emerging film industry, where he remained until passing away on February 11, 1943, at the age of seventy-four.

In 1934, Considine's old boxhouse headquarters, the People's Theatre, became the Double Header, which served as one of the first openly gay bars in the United States before closing down its doors in 2015. It has since been reopened as the Nightjay—a nightclub dedicated to dance and cabaret performances.

Lastly, the five-hundred-room brothel that was constructed during the Hiram Gill years was converted into a working-class apartment building known as the Lester Apartments. Many Boeing workers lived there, especially during World War II. In 1951, a Boeing B-29 Superfortress took off from Boeing Field and immediately developed engine trouble. As a result, the crew aboard the gigantic aircraft lost control of the plane and it clipped the top of the Rainier Brewery before pummeling into the Lester Apartments, causing a gigantic explosion and destroying the entire building. Five people were killed, with numerous other injuries. Before the fire department or ambulances could be dispatched, nearby Rainier beer workers served as first responders, using their beer delivery trucks to bring the injured to nearby hospitals.

The destruction of the Lester Apartments serves as an unfortunate but appropriate bookend to the Seattle Prohibition saga. Its narrative mirrors those in this book whose personalities helped shape one of the most

fascinating periods in the city's history, with moments of ascending glory followed by an often tragic fall from grace. In the late 1960s, an ambitious highway project reached the Seattle area, resulting in I-5 snaking its way through the middle of the city. The site of the Lester Apartments now sits entombed under this modern freeway system, emblematic of that magic era from Seattle's past which has been slowly buried and forgotten by the passage of time.

GLOSSARY OF LOCAL SLANG USED DURING PROHIBITION

bathtub gin, rotgut, snake eye: Poor quality, cheaply made moonshine, often with dangerous side effects; bad quality booze would often stink, and the saying back then was "if you could stand the smell, you could stand the drink."

blind pig: A speakeasy.

blower: A telephone.

daughter boats: The smaller, smuggling boats that would rendezvous with the floating cargo ships known as motherships.

dry agent: A Prohibition agent.

fire boat: Boat used for rum-running. Derived from "fire water," which was often a term used to describe hard alcohol.

F.O.S. (flat on sand): When delivering booze to a beach area with no docks or wharves to anchor to.

hams: Gunny sacks of booze, usually twelve bottles to a sack, with straw or sawdust typically used for packing; when rumrunners would rendezvous with other ships, the "hams" would be loaded onto their boats.

highbinder: A corrupt politician.

jumping the line: When a smuggling ship crossed the official boundary separating Canadian and American waters.

knockover: When a large inventory of illegal booze, usually hidden in a warehouse or apartment, would get confiscated by Prohibition agents or stolen by bootlegging competitors; to steal a load of booze.

land agent: A person who would broker deals between Canadian export houses (such as Consolidated Exporters) and American bootleggers; the land agents worked in established offices up and down the West Coast.

landing liquor: Delivering booze by boat.

landrunners: What rumrunners called bootleggers who use trains and cars.

let it ride: the same as "shooting it," but "let it ride" meant payment was collected upon delivery.

motherships: giant cargo ships full of booze, usually from Consolidated Exporters, which would anchor near American waters and serve as floating warehouses for American rumrunners to pick up shipments of booze from.

pot: A moonshine still.

rum chasers, hooch hounds: Coast Guard ships used for capturing smuggling boats.

shoot it: when delivering a boatload of liquor, "shooting it" meant that the customer was required to pay in advance.

soused, swacked, tanked, whiffed: To be drunk on alcohol.

stool pigeon: a person acting as an informant to the police.

swamper: an assistant who helped on smuggling boats or in bootlegging operations.

taking sugar: accepting illegal tips, bribes or payoff money.

BIBLIOGRAPHY

Books

Behr, Edward. *Prohibition: Thirteen Years that Changed America*. New York: Arcade Publishing, 2011.

Clark, Norman H. *Deliver Us from Evil: An Interpretation of American Prohibition*. New York: W.W. Norton, 1976.

————. *The Dry Years: Prohibition and Social Change in Washington*. Seattle: University of Washington Press, 1965.

Delay, Jewelli. *The Gentleman Bootlegger: The Story of Frank Gatt*. Portland, OR: Inkwater Press, 2013.

Gibson, Elizabeth. *Outlaw Tales of Washington: True Stories of Washington's Most Nefarious Crooks, Culprits and Cutthroats*. Guilford, CO: Globe Pequot Press, 2002.

Metcalfe, Philip. *Whispering Wires: The Tragic Tale of an American Bootlegger*. Portland, OR: Inkwater Press, 2007.

Mole, Rich. *Rumrunners and Renegades: Whisky Wars of the Pacific Northwest, 1917–2012*. Vancouver, BC: Heritage House, 2013.

Morgan, Murray. *Skid Road: An Informal Portrait of Seattle*. Seattle: University of Washington Press, 1951.

Newsome, Eric. *Pass the Bottle: Rum Tales of the West Coast*. Custer, WA: Orca Book Publishers, 1995.

Okrent, Daniel. *Last Call: The Rise and Fall of Prohibition*. New York: Scribner, 2011.

Parker, Marion and Tyrrell, Robert. *Rumrunner: The Life and Times of Johnny Schnarr*. Seattle: Orca Book Publishers, 1988.

Speidel, William C. *Sons of Profits*. Seattle: Nettle Creek Publishing, 1967.

Articles

Delmar, Arthur. "Rumrunner." *Northwest Powerboat*, May 1986.

Lonsale, A.L. "Rumrunners on Puget Sound." *American West*, November 1972.

Mortenson, Lynn O. "Black Nights and Bootleg Booze." *Peninsula Magazine*, Summer 1993.

Unpublished Works

General Records, Prohibition in the Pacific Northwest, Record Group 56, Box 1 (folders 3.01 – 237), Box 2 (folder 70.5) and Box 31 (folder 2440-M), National Archives Building, Seattle, WA.

Newspapers (archives)

Seattle Post-Intelligencer
Seattle Star
Seattle Times

Websites

BreweryGems.com.
Depts.Washington.edu.
En.Wikipedia.org.
HistoryLink.org.

ABOUT THE AUTHOR

Brad Holden is a local historian, collector and self-proclaimed urban archaeologist, in which he searches for historical artifacts at estate sales and flea markets and in dusty old attics. He showcases these historical finds on his Instagram page, seattle_artifacts@instagram.com, as well as in exhibits he hosts at local venues. Brad also volunteers his time at the Edmonds Historical Museum. This is his first published book.